HADRIAN'S WALL
THROUGH TIME
Alan Michael Whitworth

Acknowledgements

I wish to thank both Ackworth School for their support in this publication, Tim Padley at Tullie House Museum, Carlisle, for permission to use the photograph 91B and especially David Breeze for his comments, suggestions and corrections which are greatly appreciated. Photographs 34B, 35B and 36B are from the Clayton collection at Chesters Fort Museum managed by English Heritage. If there are any mistakes they are mine alone.

First published 2012

Amberley Publishing
The Hill, Stroud
Gloucestershire, GL5 4EP

www.amberley-books.com

Copyright © Alan Michael Whitworth, 2012

The right of Alan Michael Whitworth to be identified as the Author of this work has been asserted in accordance with the Copyrights, Designs and Patents Act 1988.

ISBN 978 1 4456 0894 5

British Library Cataloguing in Publication Data.
A catalogue record for this book is available from the British Library.

Typeset in 9.5pt on 12pt Celeste.
Typesetting by Amberley Publishing.
Printed in the UK.

Introduction

Hadrian's Wall, the most iconic symbol to the Roman presence in Britain, was built during the reign of the emperor Hadrian and crossed the country between Wallsend on the River Tyne in Northumberland and Bowness on the Solway coast in Cumbria. Construction began *c.* AD 122 and when finished the structure formed the northern frontier of the Roman Empire for close to 300 years. After the Roman withdrawal from the province of *Britannia* the Wall no longer functioned as the frontier and fell into disuse although the Venerable Bede, writing in AD 731 at Jarrow monastery, indicates that some form of urban organisation continued for perhaps 250 years after the end of the Roman period Between the seventh–tenth centuries the Anglo-Saxons and the Scandinavians all had an influence in the region but it was the Norman Conquest and its aftermath that had the major impact with the establishment of new settlements and a renewed building programme of churches and castles. In the thirteenth and fourteenth centuries early maps of the British Isles depict the Roman Wall showing that it had survived as a major feature and was still evident in the landscape. In the nineteenth century there was an increased awareness of historical monuments and their survival with a number of antiquarians beginning excavations and publishing reports.

James Irwin Coates (1848–1925), who trained as a Quaker teacher, developed an interest in archaeology while at Ackworth School in Yorkshire and it was during his time there that he visited the Wall and was stimulated by the excavations then being undertaken. Between 1877–1896 he made a total of nine visits to the Roman Wall to draw and record all that was still visible as well as what was being uncovered. His drawings are detailed and are an accurate depiction of the monument in the latter part of the nineteenth century.

He also drew a number of the artefacts that were being unearthed on excavations and placed in museums so it can be assumed that he was on friendly terms with the various antiquarians of the day who were involved in excavations along the line of the Wall. The 165 9 inch x 6 inch sepia colour-wash drawings he produced form a unique archive of what was then visible of the monument from Wallsend to Bowness at the end of the nineteenth century. Coates produced these drawings in his private capacity as an enthusiastic amateur with a great interest in recording the remains of the former Roman frontier as it was beginning to be swallowed up by housing and industrial developments, especially between Wallsend and Newcastle. The drawings also show that windmills were still in use at this period.

Upon his death in 1925 the drawings made by Coates stayed with the family until 1948 when they were presented to Ackworth School by one of his sons, to commemorate the centenary of his father's birth. He wrote: 'I have in my possession what I believe to be a unique collection of original sketches of the Roman Wall across the counties of Northumberland and Cumberland. These water colour sketches (in sepia) were drawn by my father on the spot and form a complete record of Hadrian's Wall, as then existing. If, in your opinion, this illustrated record

of the historical Wall would be of value to the school library, and could be exhibited from time to time ..., it will give me great pleasure to present it to Ackworth School. I should like to perpetuate my father's name as a worthy Ackworthian and would suggest that the exhibit be known as the James Irwin Coates collection.' The drawings are filed in a wooden box with an inscribed metal plaque, which reads: 'Pictorial record of the Roman Wall drawn by James Irwin Coates MA, scholar, apprentice and master at Ackworth School 1858–1872. Presented to the library by his sons A. I. and B. G. Coates on the centenary of his birth 26th June 1848.' The box also contained an annotated map of the Roman Wall which had been surveyed and drawn by Henry MacLauchlan between 1852–54 for the Duke of Northumberland. This set of drawings form one of the most important pictorial archives of the Wall known to exist. The original drawings are held by Ackworth School in Pontefract, Yorkshire.

From 1986 until 2000 the author worked as the Hadrian's Wall Recording Archaeologist for English Heritage on the project to record all of the exposed surviving sections of the Wall, turrets, milecastles and forts as part of the Management Plan of the monument. In 1987 Hadrian's Wall was confirmed as a World Heritage Site and now forms an integral part of the Roman Empire World Heritage Site.

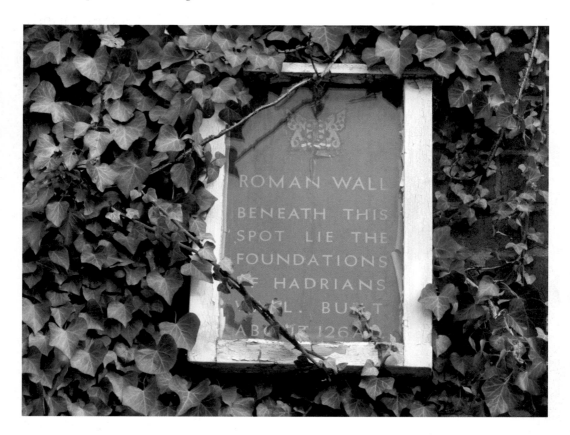

The plaque mentioning the position of the Wall is at the corner of Scotland Road and Church Terrace, Stanwix, Carlisle, between the fort of *Petriana* and the River Eden.

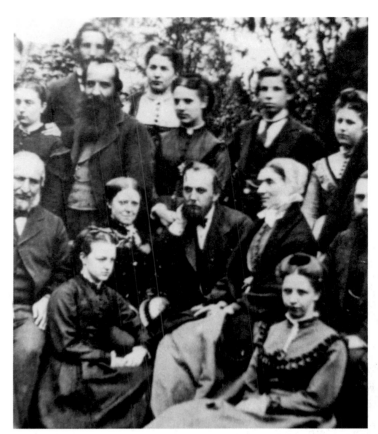

James Irwin Coates
James Irwin Coates, together with other Quaker teachers from Ackworth School, Yorkshire, is seated in the middle of the photograph which was taken sometime between 1869–72. The box together with the drawings and map are held in the school archive.

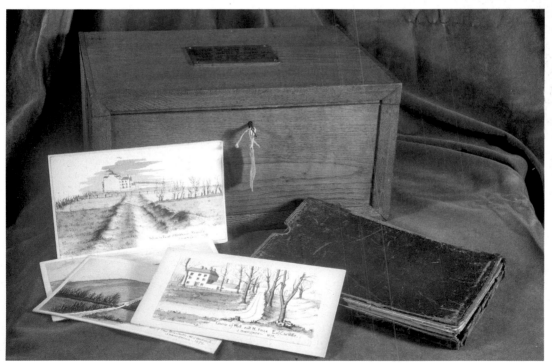

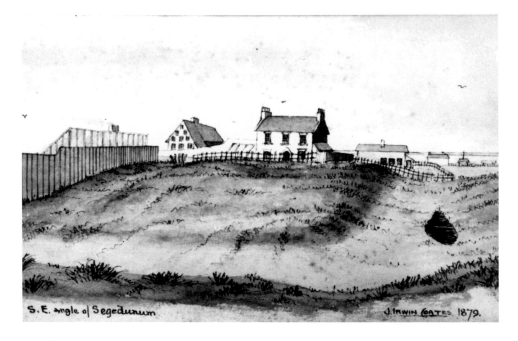

S.E. angle of Segedunum J. Irwin Coates 1879.

Segedunum Fort

Wallsend fort (*Segedunum*), measuring 4.1 acres (1.66 ha), was constructed east of Newcastle on the west bank of the River Tyne. In the mid-eighteenth century coal mining was taking place on the site and numerous buildings were being erected over the fort. Excavations between 1975 and 1984 uncovered a large part of the fort and in 2000 a new museum and viewing tower as well as a re-constructed roman bathhouse were opened to the public. Between 1993–96 a section of the Wall slightly west of the fort was re-constructed to its full height.

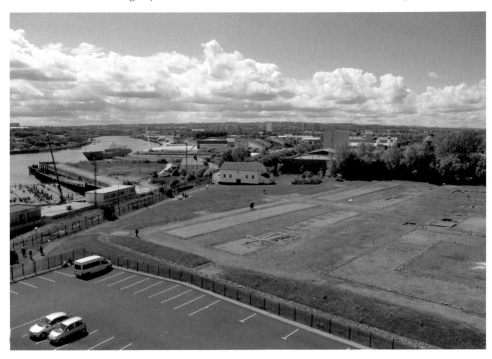

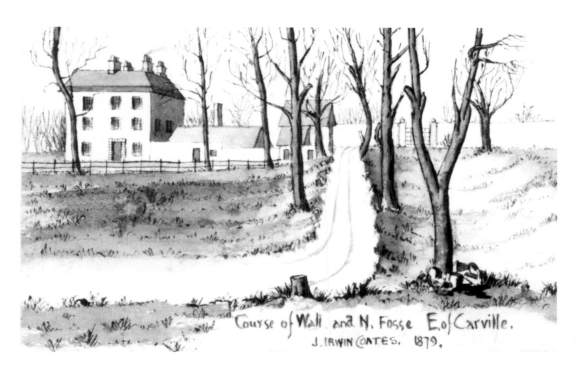

Course of Wall and N. Fosse E. of Carville.
J. IRWIN COATES, 1879.

Carville Hall

Previously known as Cosyns House, it was demolished and rebuilt in 1770 by Robert Carr and renamed Carrville Hall. This was eventually pulled down in the late nineteenth century. Urban housing now lies over the site but the name is perpetuated in names such as Carville Gardens whose residents enjoy talking about the Wall.

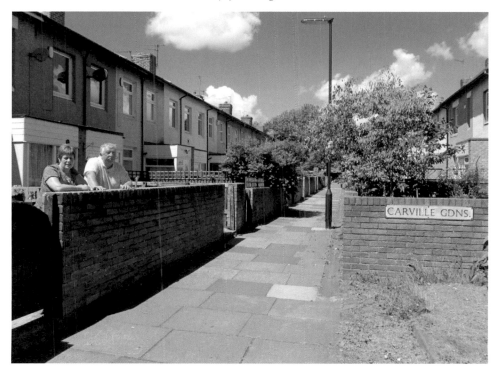

CARVILLE GDNS.

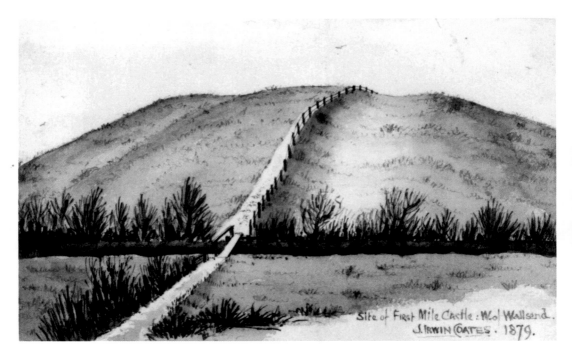

Milecastle 1

Milecastle 1 had been built on the west side of the Stott's Pow and is now located buried under part of the recreation ground, Miller's Dene on Fossway. The Fossway Bowling Club now has its green adjacent to the line of the Wall. Fosse comes from the Latin *fossa* for ditch or trench.

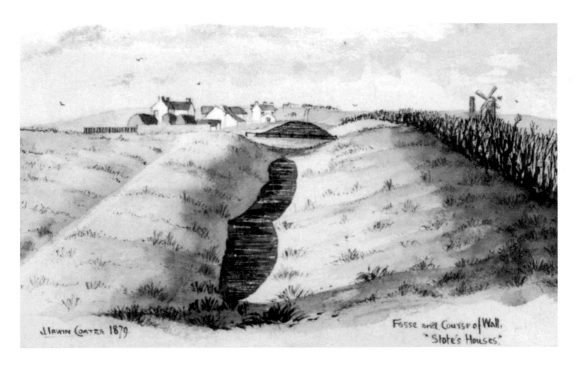

J. IRWIN COATES 1879.

Fosse and Course of Wall, "Stote's Houses"

Stote's Houses

Stote's Houses was called Beehouses in 1732 by the antiquarian John Horsley. Walker Corn Mill is shown on the north side of the Wall and in the distance is the village of Old Wall. Today the junction of Fossway and Stott Road is a busy roundabout and the view drawn by Coates has disappeared.

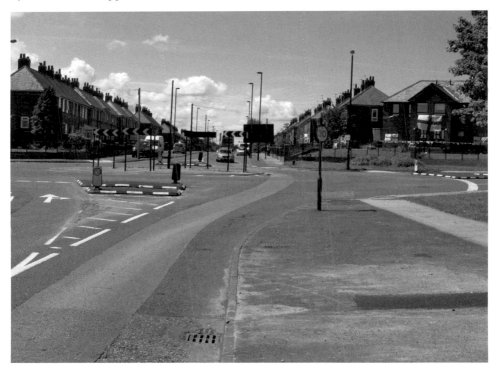

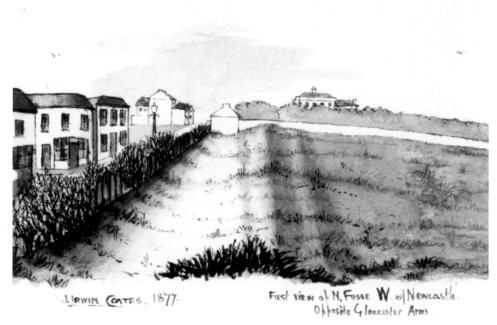

J. IRWIN COATES. 1877.

First view of N. Fosse W. of Newcastle. Opposite Gloucester Arms.

Westgate Road

Heading west out of Newcastle the Westgate Road followed the line of the Wall and the north ditch. The Gloucester Arms public house is depicted with a gas lamp nearby. The mounds of the ditch appeared as soon as the last houses past Gloucester Road had been passed according to the antiquarian John Collingwood Bruce in 1863.

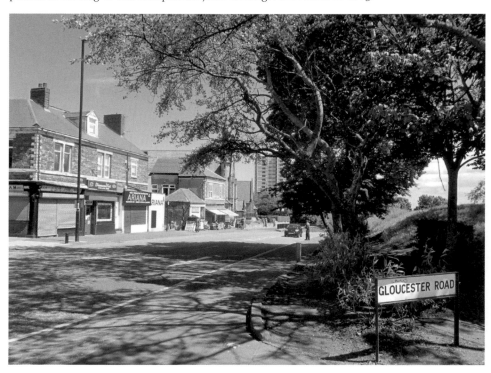

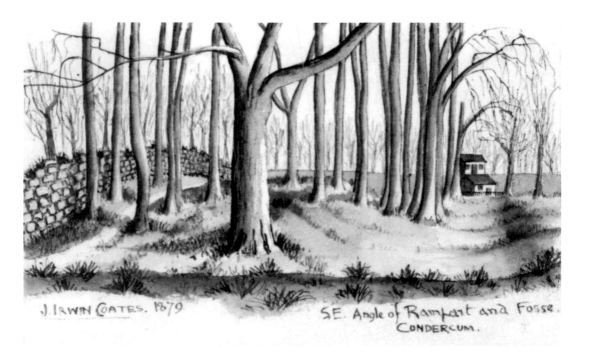

J. IRWIN COATES. 1879.

S.E. Angle of Rampart and Fosse. CONDERCUM.

Condercum Fort

The south-east angle of Benwell fort (*Condercum*), showing a line of trees along the east ditch and a stone wall presumably of re-used Roman material. Housing from the mid-1930s now covers most of the fort although the Vallum crossing outside the south gate has been excavated and preserved and can be seen at Denhill Park Avenue.

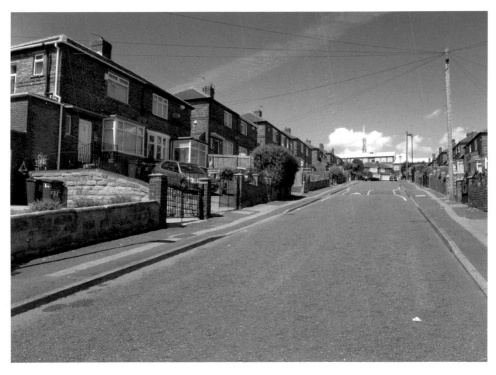

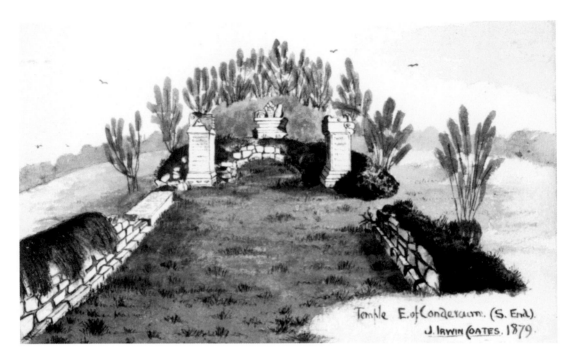

Temple E. of Condercum. (S. End).
J. Irwin Coates. 1879.

Temple of Antenociticus

Close to Benwell fort, in Broomridge Avenue, is the temple of Antenociticus, probably a native Celtic god. The original Roman altars, together with the stone-cut head of the god are now in the Great North Museum, Newcastle. Discovered in 1862 the temple was consolidated in 1936 by Charles Anderson of the Ministry of Works. The monument is in the care of English Heritage.

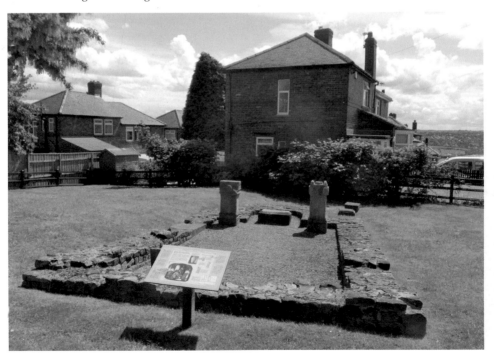

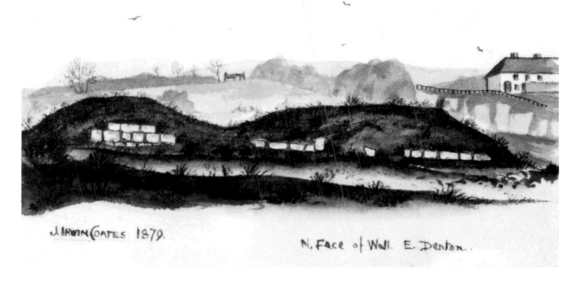

J. IRWIN COATES 1879.

N. Face of Wall. E. Denton.

Denton Burn

This small section of Wall is located in Denton Burn, Newcastle, and was shown in a depiction drawn in 1863 with an apple tree growing on it. It is the first substantial length of Wall that can be seen west of Newcastle.

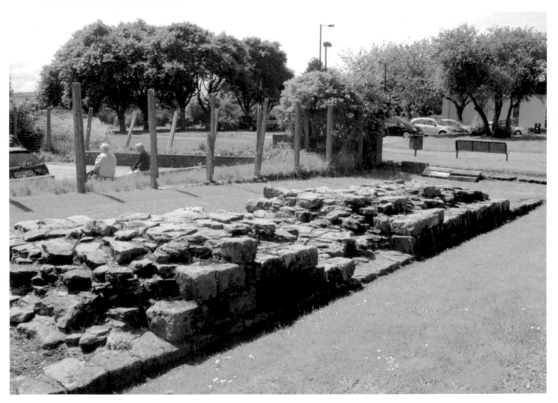

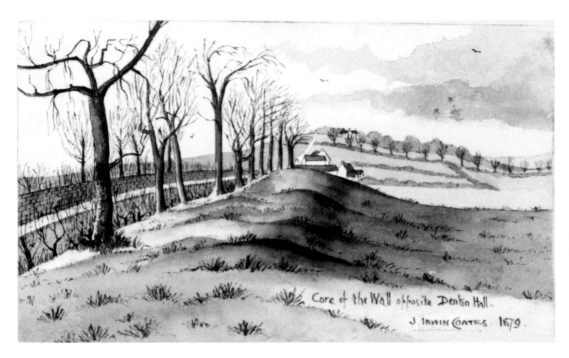

Core of the Wall opposite Denton Hall.
J. IRWIN COATES. 1879.

Turret 7b

When Coates drew this scene in 1879, turret 7b at Denton had not been located, and the surrounding countryside was mainly farmland. The site was excavated in 1929 by which time housing had spread westward from Newcastle as the population increased and the high demand for housing needed to be satisfied.

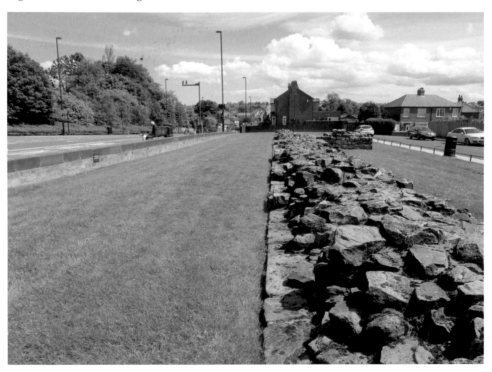

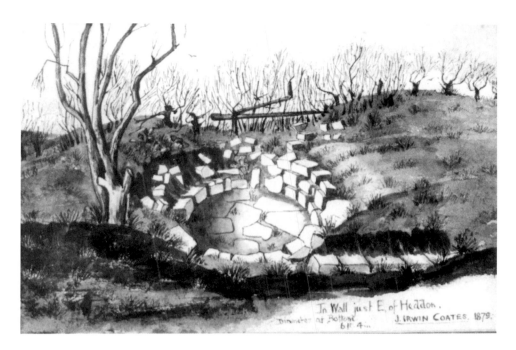

In Wall just E. of Heddon. Diameter at Bottom 6ft 4... J. IRWIN COATES. 1879.

Heddon-on-the-Wall

At Heddon-on-the-Wall a section of Broad Wall survives up to 7 courses high, with some of the stones retaining traces of white Roman mortar. A circular medieval kiln has been inserted into the Wall face at the west end. The site is a stopping off point for visitors on their way from Newcastle to visit the various forts in the central section of the Wall.

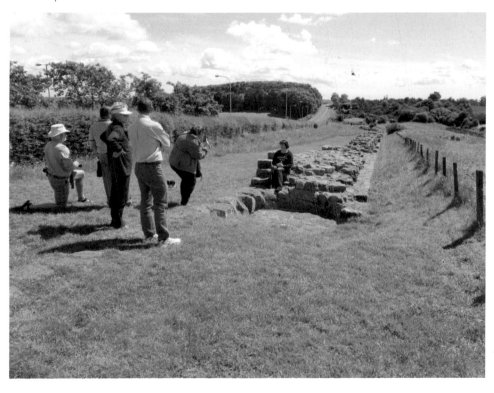

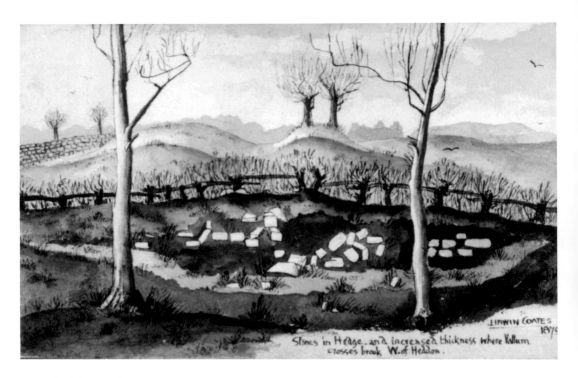

Stones in Hedge and increased thickness where Vallum crosses brook W. of Heddon.

J. IRWIN COATES 1896

Rudchester Burn

The Wall crosses the Rudchester Burn (stream) at this point and on the left-hand side the Newcastle–Carlisle turnpike road is flanked by a stone wall. The A69 Carlisle–Newcastle trunk road now crosses the line of the Wall and a Roman culvert carrying the Rudchester Burn under the Wall was seen in 1974 during roadwork construction.

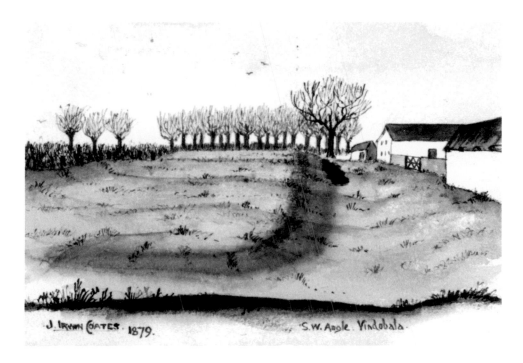

J. IRWIN COATES. 1879. S.W. Angle Vindobala.

Rudchester Fort

Rudchester fort (*Vindobala*) covers 4.5 acres (1.8 ha) and straddles the B6318. Partially excavated in 1924 and 1972 only the humps and bumps of walls and the outline of ditches are now visible. Outside the fort was a temple to Mithras containing five altars. A life size statue of Hercules, now in the Great North Museum, Newcastle, was found here in 1760.

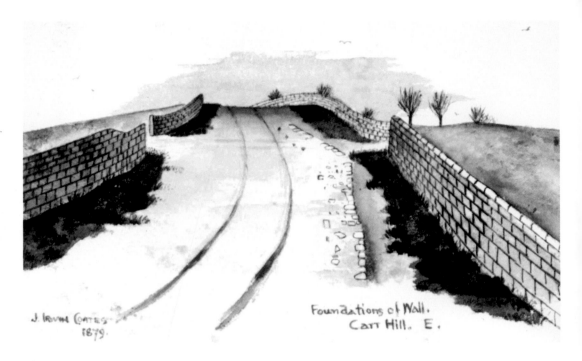

J. Irvine Coates
1879.

Foundations of Wall.
Carr Hill. E.

Close to Turret 20a

The drawing, which shows remains of the Wall visible in the road surface close to turret 20a, indicates that Coates was keen to record any intact remains of the Wall structure. The Military Road (B6318) now has a tarmac surface protecting the remains from any future damage.

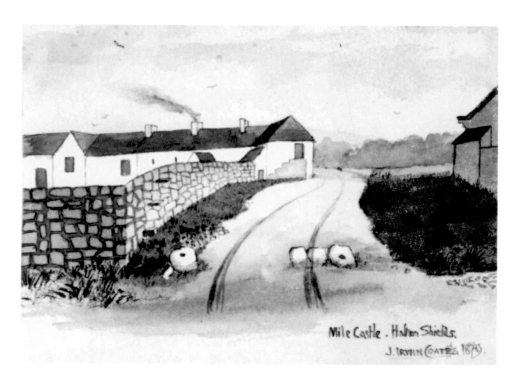

Mile Castle. Halton Shields.
J. IRWIN COATES 1879.

Halton Shields

Halton Shields hamlet is the site of milecastle 20. Cart tracks cross what appears to be Roman gate pivot blocks and the enclosure wall looks as though re-used Wall stone has been utilised in its construction.

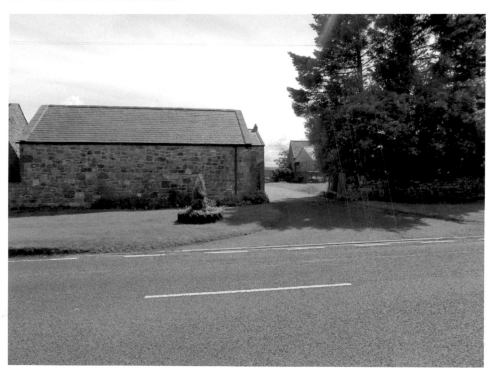

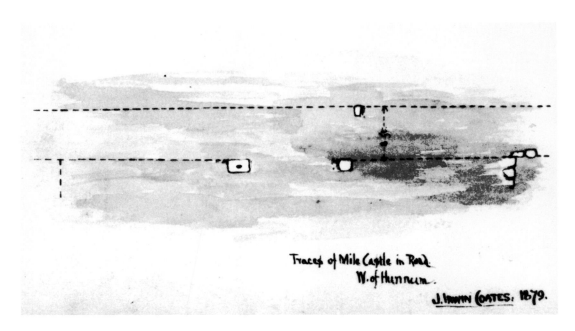

Traces of Mile Castle in Road.
W. of Hunnum.
J. Irwin Coates, 1879.

Milecastle 22

Milecastle 22 is situated just east of the Roman road Dere Street, the modern A68, as it headed north from York via Corbridge Roman fort (*Corstopitum*) into Scotland. Where it crossed the frontier a major gateway stood called Portgate. The Errington Arms now stands at the crossroads offering refreshments to Wall trail walkers and A68 users alike.

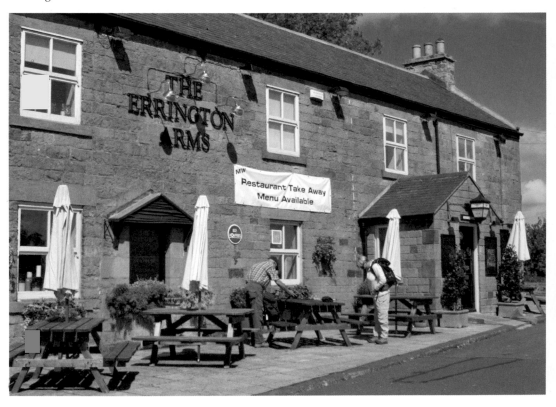

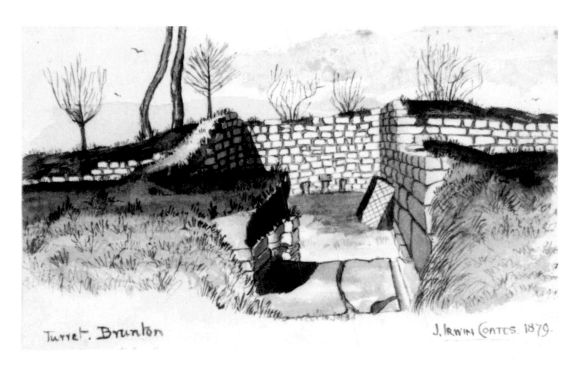

Turret. Brunton

J. IRWIN COATES. 1879.

Brunton Turret

Brunton turret (26b) was excavated by John Clayton in 1878 and 1880, either side of Coates' visit. Three small altars resting against the north wall are no longer there and the turf covering removed when the turret was consolidated by the Ministry of Works in 1948 using a cement based mortar.

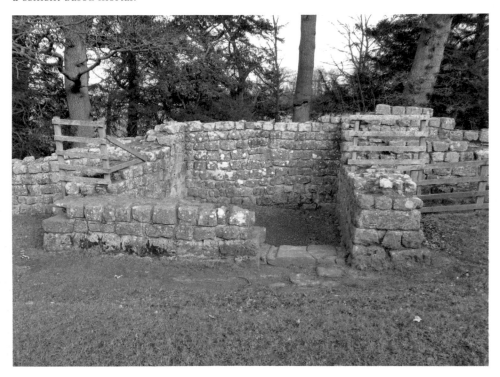

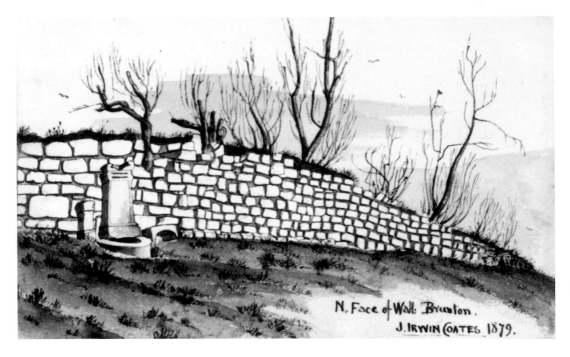

N. Face of Wall. Brunton.
J. IRWIN COATES 1879.

Brunton Turret

The north side of Brunton turret and length of Wall was exposed and cleaned up in 1948. The larger of the two altars had been removed 100 years earlier from St Oswald-in-Lee church (Heavenfields) to Brunton House and then to this position. It has now been returned to the nave of the church. Several churches close to the Wall have Roman altars re-used as baptismal fonts.

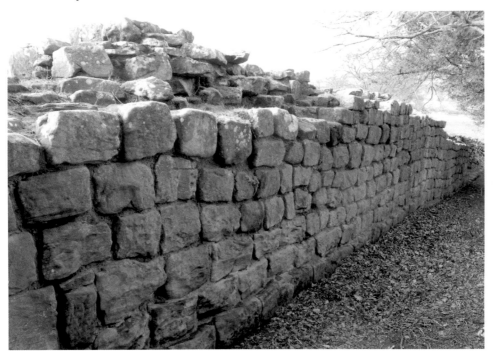

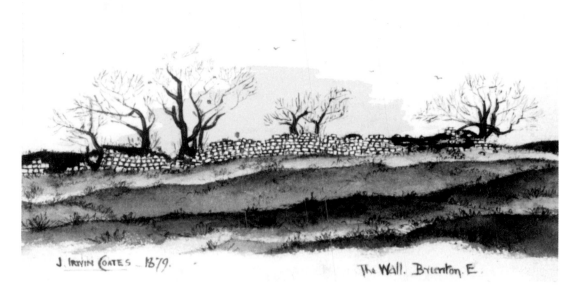

J. IRVIN COATES - 1879. The Wall. Brunton. E.

Planetrees

East of the turret 26b is a length of Wall known as Planetrees and was the section mentioned by William Hutton on his visit along the Wall in 1801, when he implored the owner to desist from digging out the facing stones for building material for a farmhouse as 95 yards (86 metres) had already been destroyed. This section of Wall consists of both Broad Wall and Narrow Wall as well as a drainage channel at foundation level inserted during the initial construction phase.

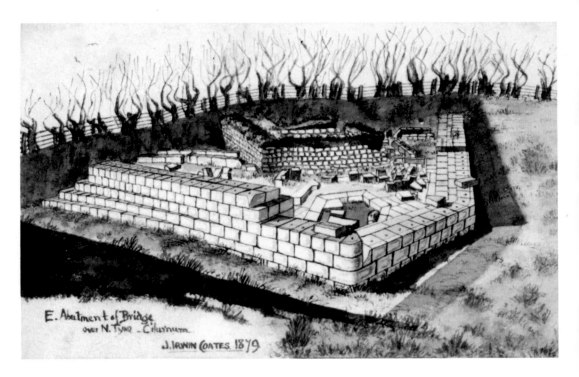

E. Abutment of Bridge over N. Tyne — Cilurnum

J. IRWIN COATES 1879

Chesters Bridge I

Four major river crossings were bridged along the Wall line: the Tyne at Newcastle and Chesters, the Irthing at Willowford and the Eden at Carlisle. The east abutment of Chesters Bridge was uncovered in 1863. Many of the blocks have marking-out lines as well as lewis holes for lifting and Roman lead is still visible in some of the joints. A phallic symbol, for good luck, is carved on one of the facing stones.

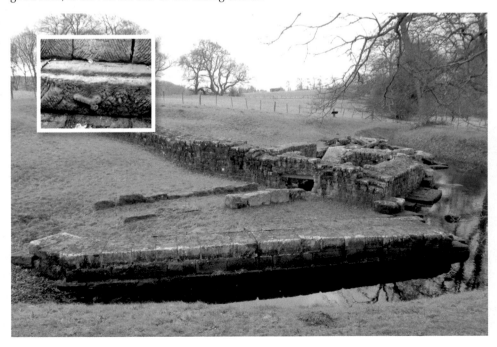

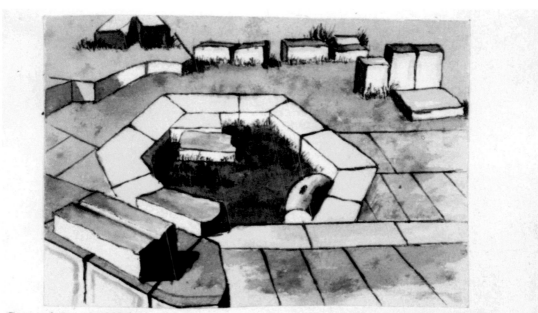

Pier of Original Bridge over N. Tyne. Cilurnum.

J. IRWIN COATES 1879

Chesters Bridge II
Part of the bridge structure over the Tyne at Chesters shows a pier from the first bridge enclosed within masonry from the later replacement with its substantial masonry to allow a roadway to cross the river.

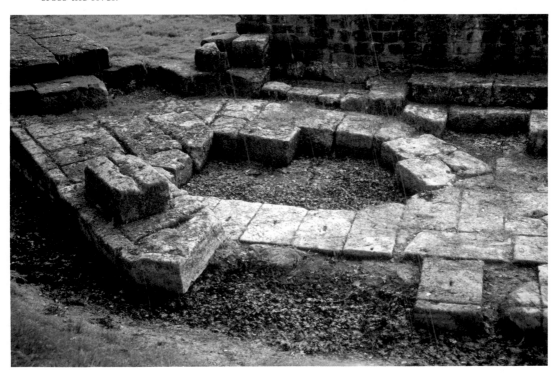

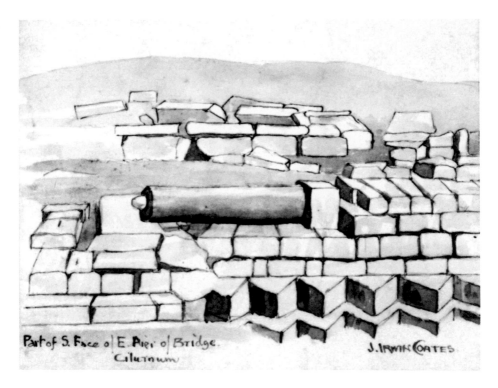

Part of S. Face of E. Pier of Bridge. Cilurnum

J. IRWIN COATES.

Chesters Bridge III

The column, of which this is the lower half, is the only complete one found at the site although fragments of three others survive. The top of the column is thought to have supported a statue.

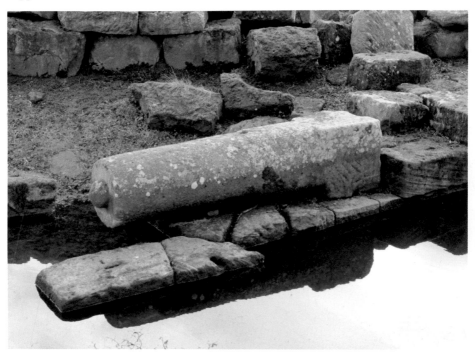

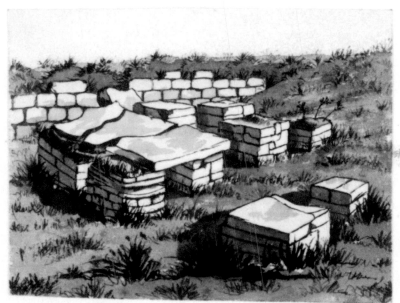

CILURNUM. 1879. J. IRWIN COATES

Chesters Fort

Chesters Roman fort (*Cilurnum*), an English Heritage site on the west side of the North Tyne, covers 5.75 acres (2.32 ha) and was part of the Clayton family estate with excavations starting in 1843. The commanding officer's house had underfloor heating as shown by the hypocausts which allowed warm air to circulate under the stone slab flooring.

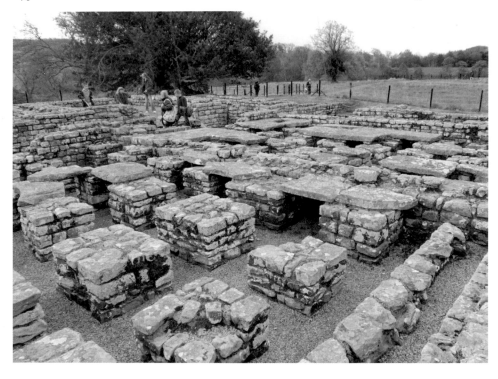

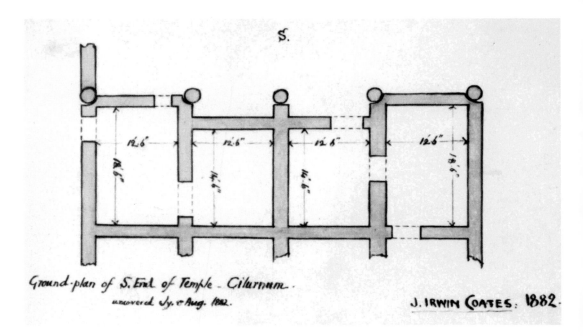

Ground-plan of S. End of Temple - Cilurnum.
uncovered Jy. & Aug. 1882.

J. IRWIN COATES. 1882.

Barrack-Blocks I, Chesters Fort

The plan shows part of the Chesters fort barrack-blocks, to house eight soldiers to a room, in the north-east quarter of the fort and not a temple as thought by Coates.

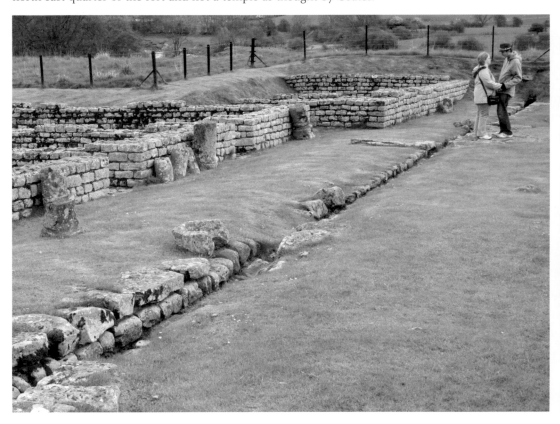

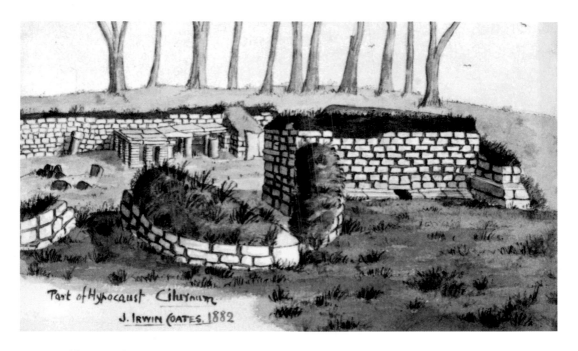

Part of Hypocaust Cilurnum
J. IRWIN COATES. 1882

Bathhouse, Chesters Fort

The commanding officer and family had their own bathhouse within their quarters. It included a dressing room, warm room, hot room with an apse and two cold baths. The hot room flooring retains the original tile columns and pillars. Original waterproof cement was seen when the buildings were excavated in the mid-nineteenth century. The garrison bathhouse is situated outside the fort overlooking the west bank of the River Tyne.

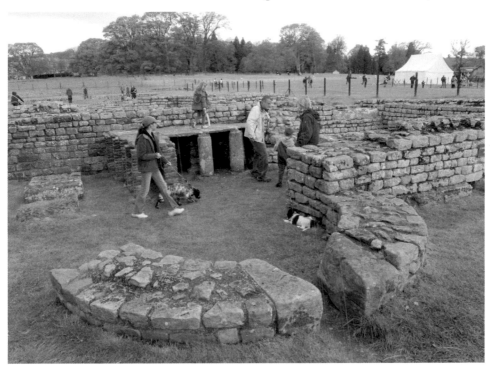

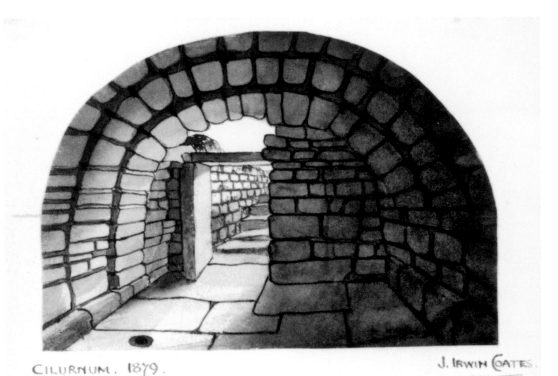

CILURNUM. 1879. J. IRWIN COATES.

Underground Strongroom, Chesters Fort

Within the headquarters building complex, down a flight of stone steps, lay the underground strongroom or bank vault where the soldiers' pay was kept. Several forged coins were found on the floor when it was being cleaned out in the nineteenth century.

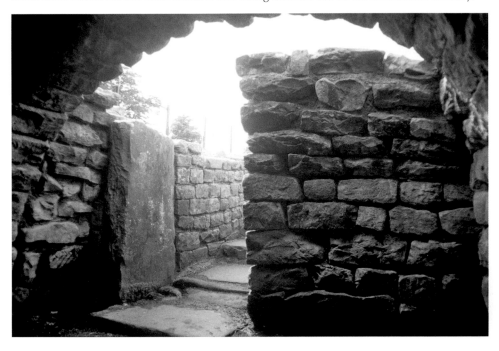

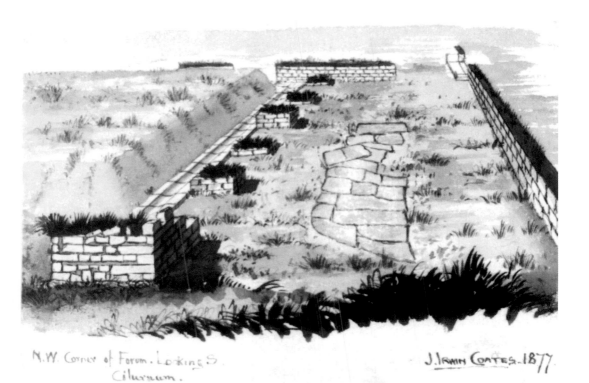

N.W. Corner of Forum. Looking S.
Cilurnum.

J. Irwin Coates. 1877

Headquarters Courtyard, Chesters Fort

The north-west side of the headquarters courtyard contained a stone-lined well. The remains of a flagged corridor and gutters to carry away rainwater from the covered collonades still remain.

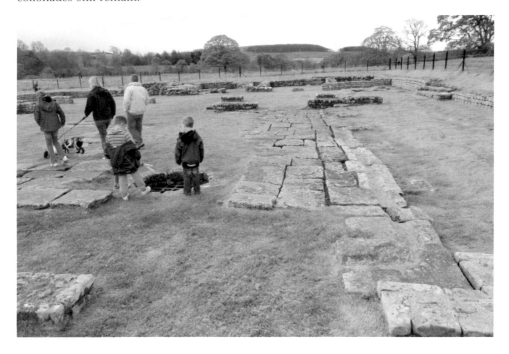

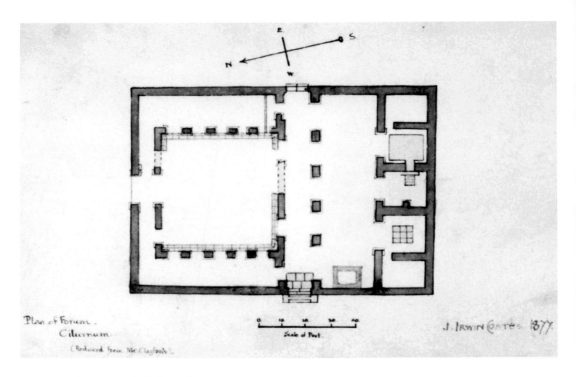

Plan of Forum.
Cilurnum.
(Reduced from Mr. Clayton's).

Scale of Feet.

J. IRWIN COATES 1877.

Headquarters Building, Chesters Fort

Coates drew a ground plan of the headquarters building. The *principia* was the most important building within the fort, containing the strongroom, the chapel of the regimental flags, the commanding officer's tribunal and office space. One of the flagstones in the courtyard contains a large phallic symbol as the Romans believed it would protect the enclosed space.

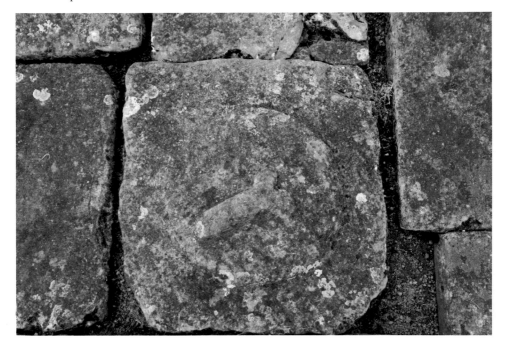

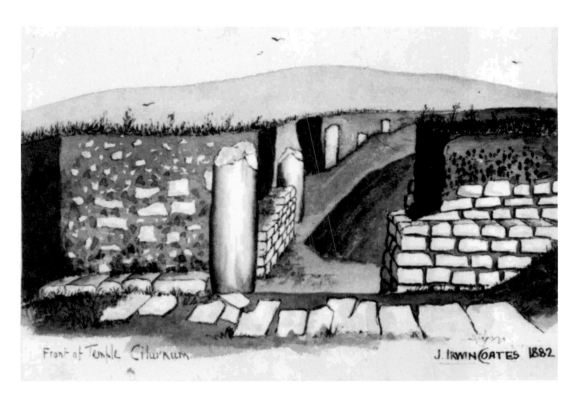

Front of Temple Cilurnum

J. IRWIN COATES 1882

Barrack-Blocks II, Chesters Fort

Part of the barrack-blocks area, not a temple as indicated by Coates. Re-enactors now show visitors of all ages some aspects of life in the fort as part of an educational and interpretational experience.

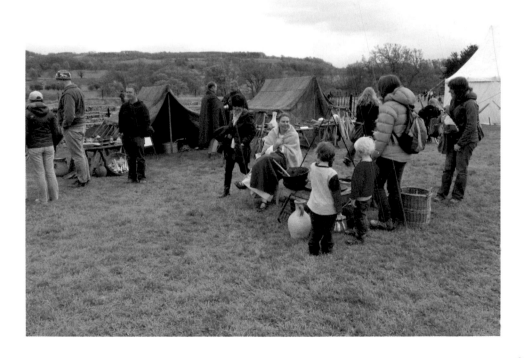

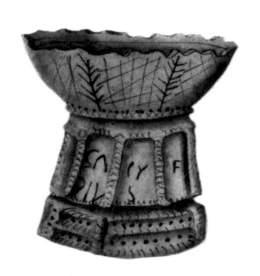
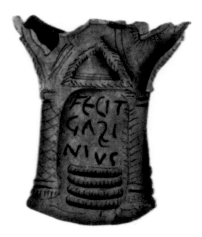

Vases found at PROCOLITIA.

J. IRWIN COATES . 1879.

Chesters Fort Museum I

Two incense burners found in a well dedicated to the water goddess Coventina, on the west side of Carrawbrough fort. Now on display at Chesters Fort Museum.

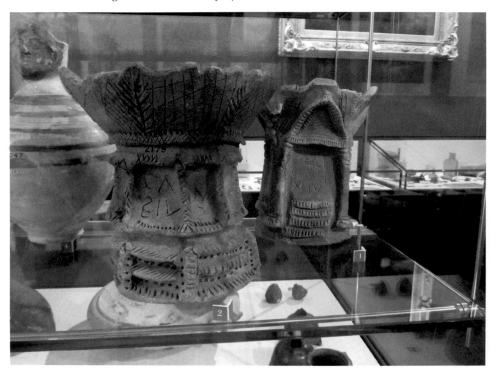

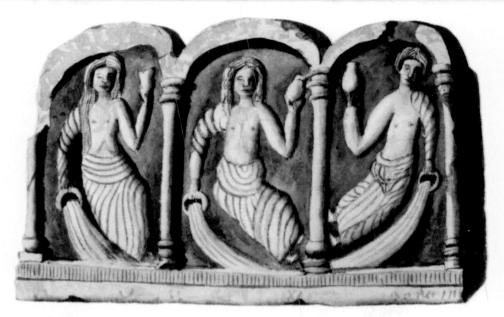

Sculptured Stone from WELL OF COVENTINA : PROCOLITIA

J. IRWIN COATES. 1882.

Chesters Fort Museum II

A stone sculpture showing three water nymphs pouring water. It was found in the Well of Coventina when it was excavated in 1876.

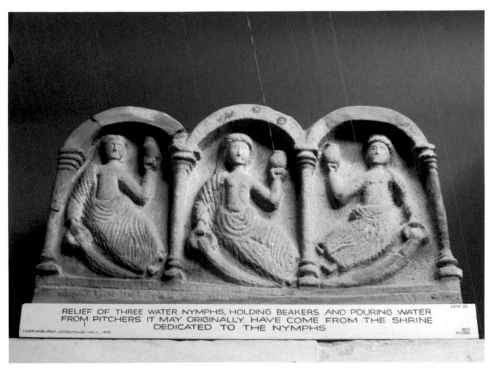

RELIEF OF THREE WATER NYMPHS, HOLDING BEAKERS AND POURING WATER FROM PITCHERS. IT MAY ORIGINALLY HAVE COME FROM THE SHRINE DEDICATED TO THE NYMPHS

CARRAWBURGH, COVENTINA'S WELL, 1876

Figure of Cybele.

found at Cilurnum J. IRWIN COATES 1882.

Chesters Fort Museum III

The statue of Juno Regina probably came from the headquarters building as she was the Queen of the Gods and Heaven and protected the Roman people. Juno, along with Jupiter and Minerva, headed the State cult. She is normally depicted wearing a royal diadem and a long dress and standing on a sacrificial heifer. The delightful 1903 museum within the grounds of Chesters site houses many of the artefacts located by John Clayton and his family in the course of the numerous excavations within various forts, milecastles and turrets along the Wall.

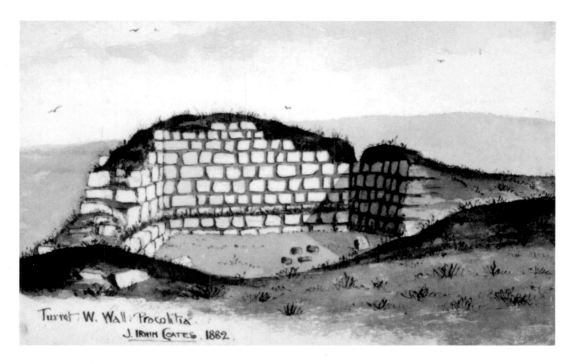

Turret. W. Wall. Procolitia.
J. IRWIN COATES. 1882.

Carrawburgh Fort

Carrawburgh fort (*Brocolitia*), first examined in 1871 when the interval tower on the west wall was uncovered, is in private ownership. Although the fort of 3.9 acres (1.6 ha) is now grass covered the outline of its walls, ditches and three of the gates are still visible under the green sward.

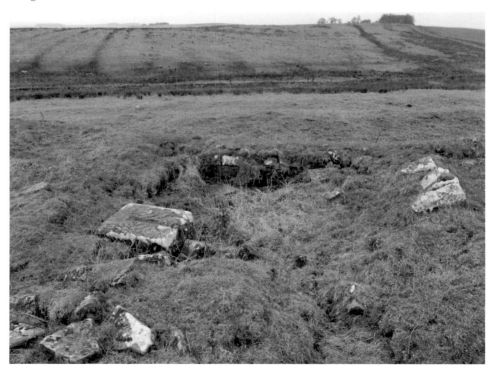

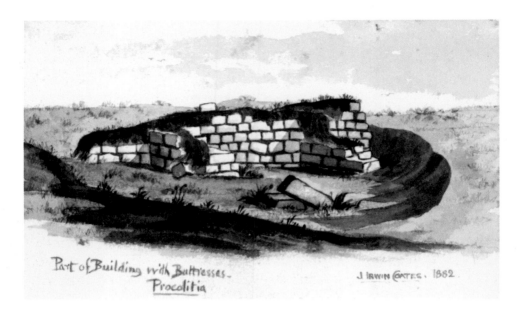

Part of Building with Buttresses.
Procolitia

J. IRWIN COATES. 1882.

Carrawburgh Granary

The buttresses of the granaries at Carrawburgh were excavated during the 1871 excavation campaign. In 1949, during a period of drought, the temple to Mithras was located to the west of the fort by a visitor who noticed the tops of the altars showing on the exposed ground surface. The following year it was excavated and consolidated. Mithras was an eastern Sun god from Asia Minor and was popular with the Roman military as it was an exclusively male cult. In 1957 during some landscaping work adjacent to the temple workmen found an altar dedicated to the Nymphs and the *Genius Loci* (the spirit of the place).

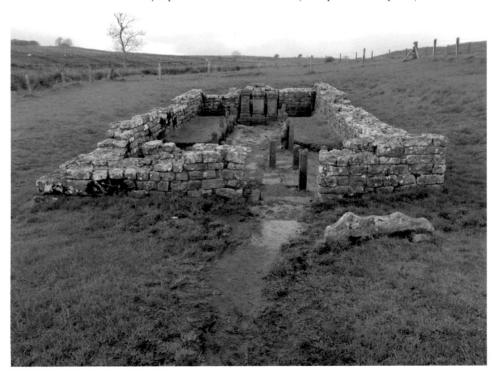

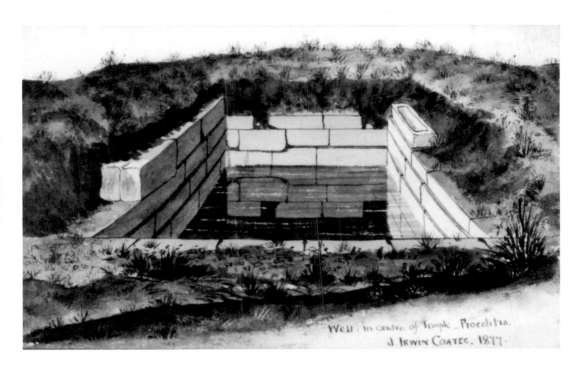

Well in centre of Temple — Procolitia.
J Irwin Coates. 1877.

Coventina's Well

Close to the Mithraic temple is Coventina's Well containing a spring water source surrounded by a stone temple enclosure. Coventina, a water goddess unknown in classical mythology, had Celtic or continental origins. When the well was excavated in 1876 it was found to contain numerous altars, offerings, votive objects and coins.

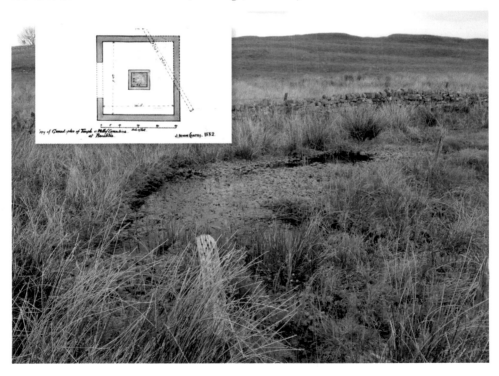

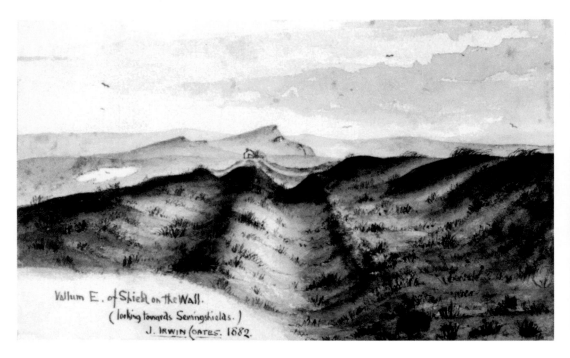

Vallum E. of Shield on the Wall.
(looking towards Sewingshields.)
J. IRWIN (OATES. 1882.

Vallum Ditch

The vallum ditch close to milecastle 33 is clearly visible and sitting astride it is the ruined cottage of Shield-on-the-Wall which was previously known as Tipplehall. South of the cottage is Shield-on-the-Wall dam and weestwards in the distance is Sewingshields Farm.

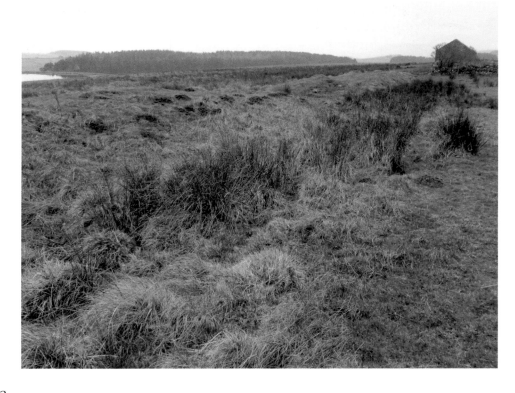

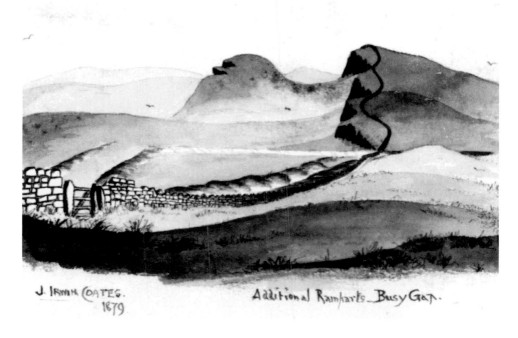

J. IRWIN COATES.
1879

Additional Ramparts. Busy Gap.

Busy Gap

Busy Gap lies west of turret 35b. The present farm field wall is constructed on top of the buried Roman Wall. A medieval drove road passed through the Gap and was used by Border Reivers, the notorious horse and cattle thieves, to move their stolen booty through the difficult terrain of the Whinsill escarpment.

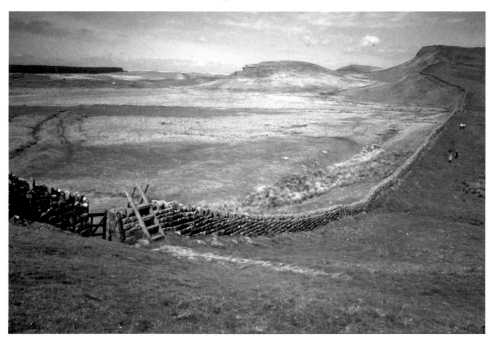

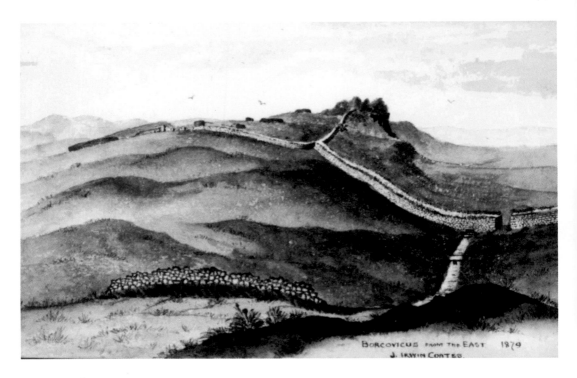

BORCOVICUS FROM THE EAST 1879
J. IRWIN COATES.

Housesteads Fort I

The view shows the Wall running up to the north-east angle of Housesteads (*Vercovicium*), the east gate of the fort and the Knag Burn gateway. Several pieces of the fort bathhouse masonry appear on the east bank of the Burn. Within the fort, the walls of several excavated buildings are visible and in the background are Housesteads woods overlooking the steep crags.

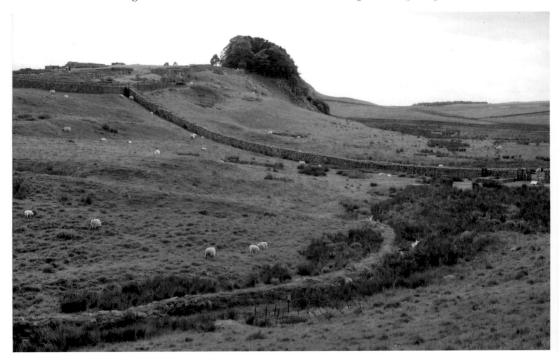

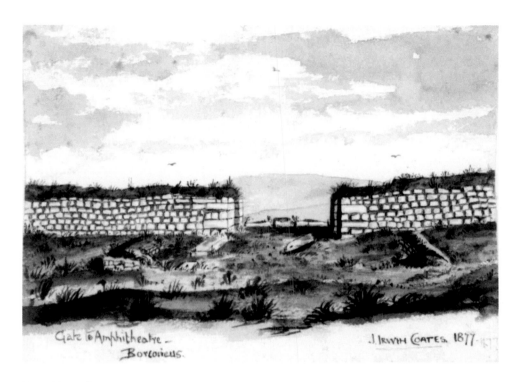

Gate to Amphitheatre -
Borcovicus.

J. Irwin Coates. 1877.

Knag Burn Gateway

The Knag Burn gateway, situated in the valley bottom east of Housesteads, is owned by the National Trust. The Wall is up to 7 courses high and there are guardhouses on either side of the passageway. The Hadrian's Wall National Trail passes through the gateway.

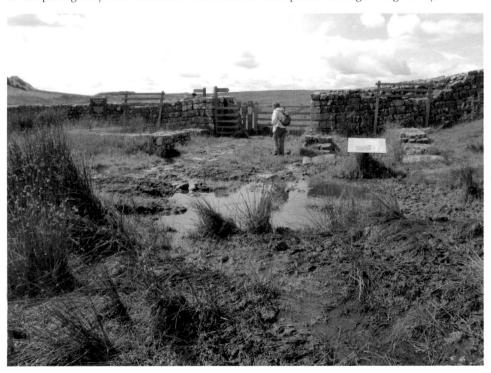

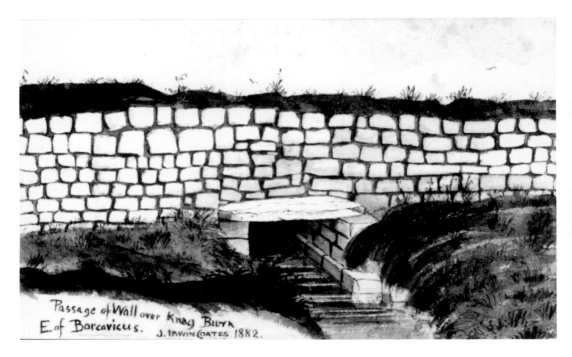

Passage of Wall over Knag Burn
E. of Borcovicus. J. IRWIN COATES 1882.

Knag Burn

The Knag Burn provided one of several water supplies to the fort. Below the fort at Chapel Hill is a spring that still flows with water which is nowadays pumped up the hill to provide water for both the museum and the National Trust holiday home. Another spring on the east side of the fort provided a constant source of water for the, now demolished, fort garrion bathhouse.

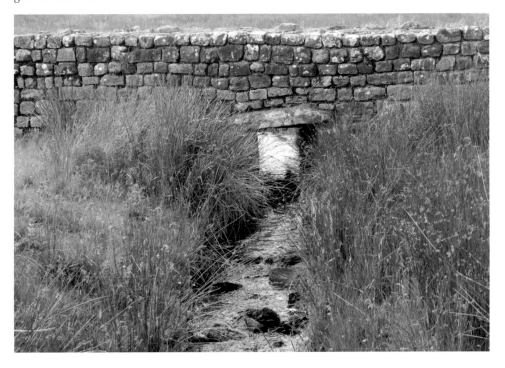

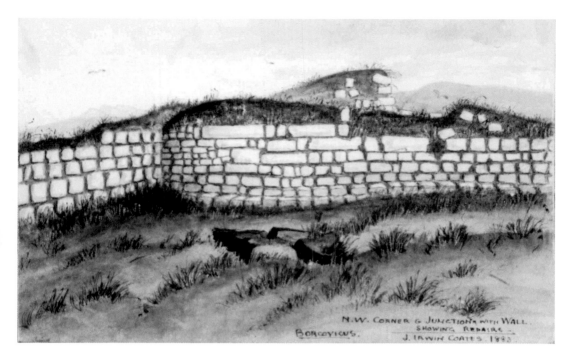

N.W. CORNER & JUNCTION WITH WALL
SHOWING REPAIRS
BORCOVICUS. J. IRWIN COATES. 1893

Housesteads Fort II

The curved north-west corner of the fort, showing evidence of Roman repairs, and its junction with the Wall were turf capped until the early 1950s when the Ministry of Public Works took over management of the site from the National Trust. The mound of the north-west angle tower within the fort is visible.

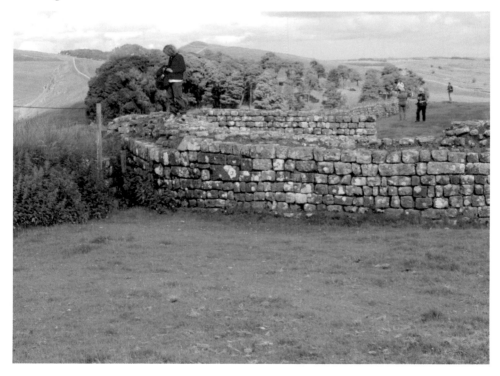

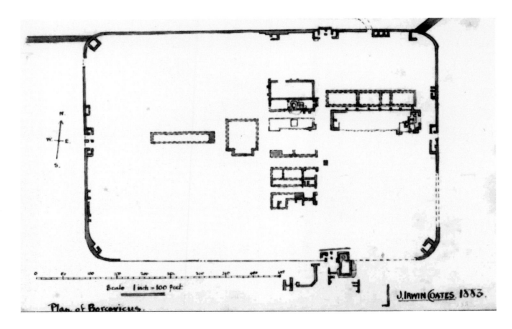

Scale 1 inch = 100 feet

Plan of Borcovicus.

J. IRWIN COATES. 1883.

Housesteads Fort Plan

The plan of the fort shows all of the excavated buildings as they appeared in 1883. The latrines, in the south-east corner and the best preserved toilet block in Roman Britain, were located in 1898 and consolidated by the Ministry of Public Works in 1963. One of the three large cisterns for the communal latrines is still visible, within which can still be seen the metal brackets and lead between the stone slab joints. The Roman drains within the fort still function as after prolonged heavy rain the water discarges into the latrine sewerage pit.

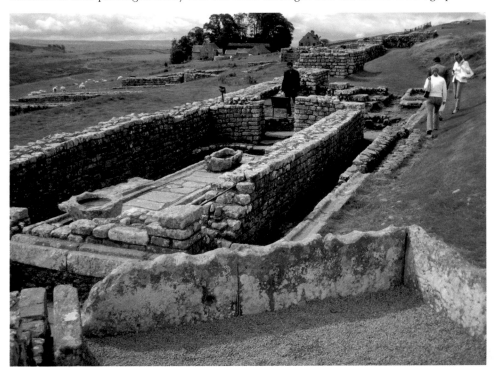

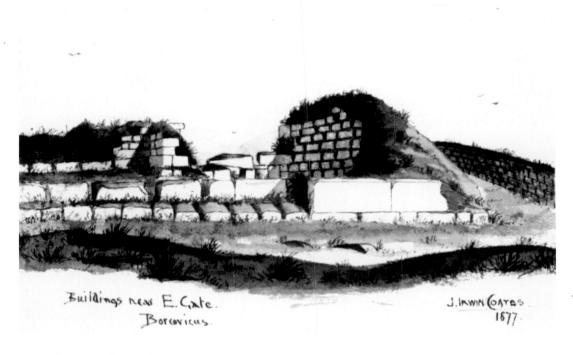

Buildings near E. Gate.
Borcovicus.

J. IRWIN COATES.
1877.

Housesteads Fort III

This large building, close to the east gate, had a variety of functions throughout its history, including storehouse and hall. A small bathhouse was constructed within it at the east end during the late fourth century. Voussoirs for the roof vaulting lie close by.

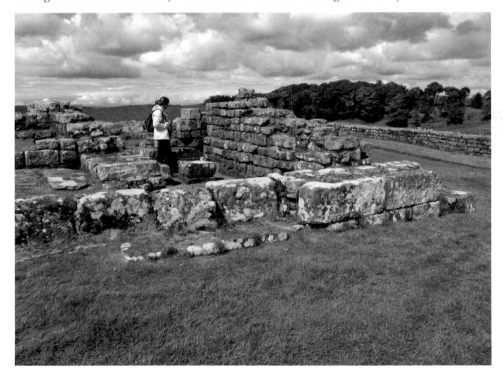

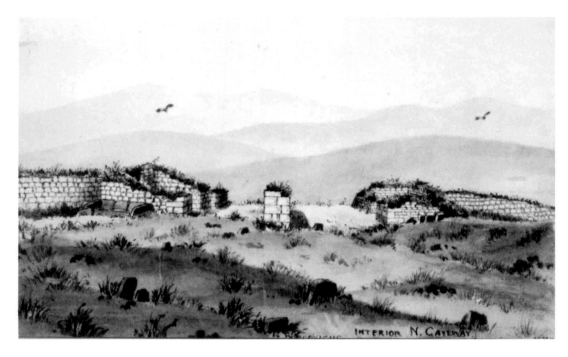

INTERIOR N. GATEWAY.

North Gate, Housesteads

The north gate of the fort, which had been excavated by 1857, is depicted with its two guard chambers and the central *spina* which helped to support the upper floors of the structure. A large stone watertank is adjacent to the west tower and would have been used to collect rainfall runoff from the tower roof. Two similar water tanks have been excavated within the fort.

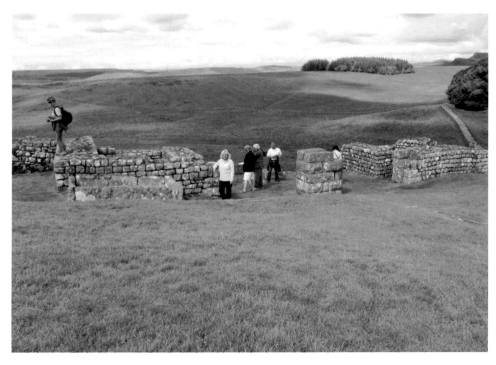

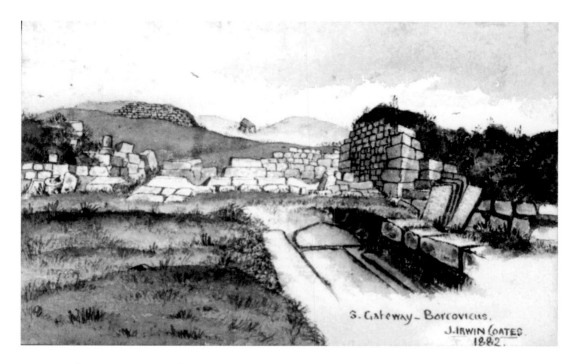

S. Gateway – Borcovicus.
J. IRWIN COATES.
1882.

South Gate, Housesteads

The south gate, now the main visitor entrance to the site, had been excavated by 1852 exposing the stone slabs of the Roman road into the fort together with the central stop-block and the wheel ruts worn into the gates threshold blocks. A seventeenth-century bastle house (fortified farmhouse) was built within the remains of the eastern guard chamber. Within the fort is part of the commanding officer's house and a partially exposed column base.

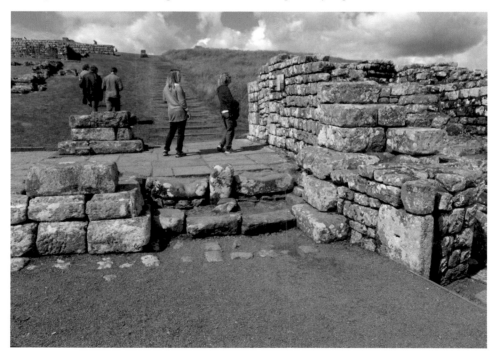

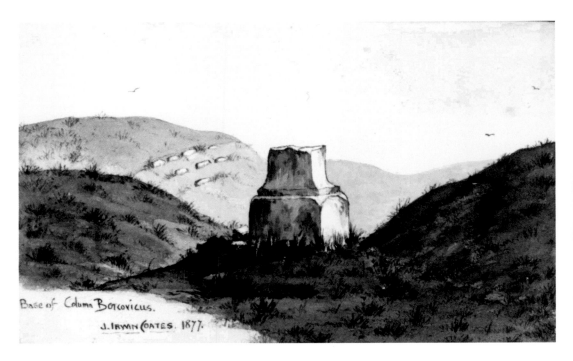

Base of Column Borcovicus.
J. IRWIN COATES. 1877.

Column Base, Housesteads

The remains of the aforementioned column base is situated on the site of the road which runs north–south through the fort. Several similar column bases are located between the north and south granaries so it is probable that it was placed in its present position during the medieval period.

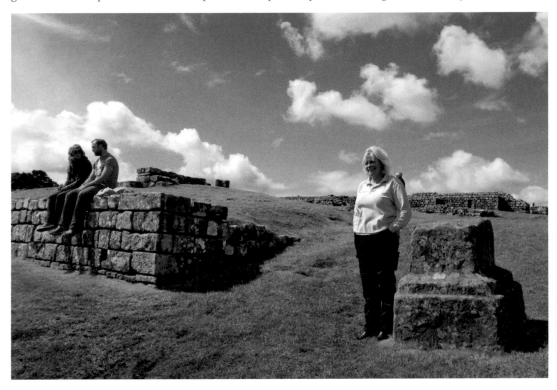

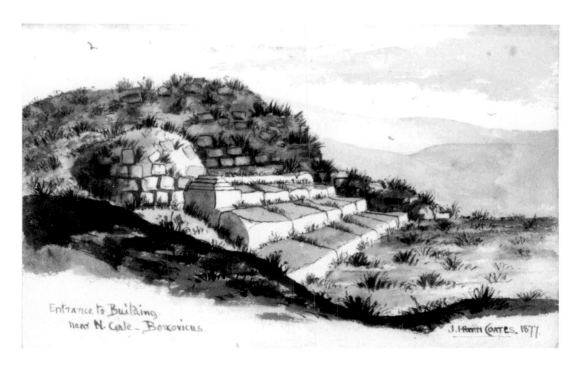

Entrance to Building.
near N. Gate - Borcovicus

J. Irwin Coates. 1877.

Granaries, Housesteads

The granaries buildings (*horea*) are situated in the central range of the fort and housed the grain and other supply of foodstuffs for the garrison. The depiction by Coates shows the steps leading into the east end of the south granary, now a popular spot for group photographs.

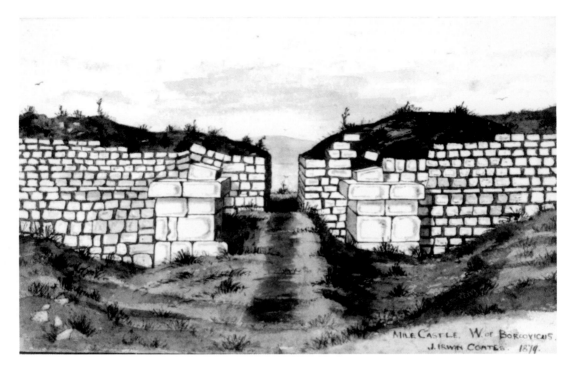

Mile Castle. W. of Borcovicus.
J. Irwin Coates. 1879.

Milecastle 37

Milecastle 37, first excavated in 1853, and one of the best preserved along the Wall, shows the north gateway and arch voussoirs as well as the later inserted blocking wall. Several voussoirs found in the vicinity of the milecastle were added in later years to the north gate. Sited just west of Housesteads fort it attracts many visitors.

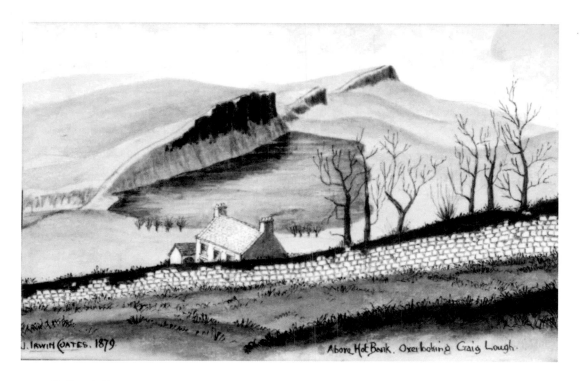

J. IRWIN COATES. 1879

Above Hot Bank. Overlooking Craig Lough.

Hotbank Farm

One of the most photogenic views along the Wall is above Hotbank Farm (Milecastle 38) looking west towards Highshield Crags and Crag Lough. A building inscription by the Second Legion, found in the debris of the milecastle, confirmed that the Wall was constructed during the reign of Hadrian.

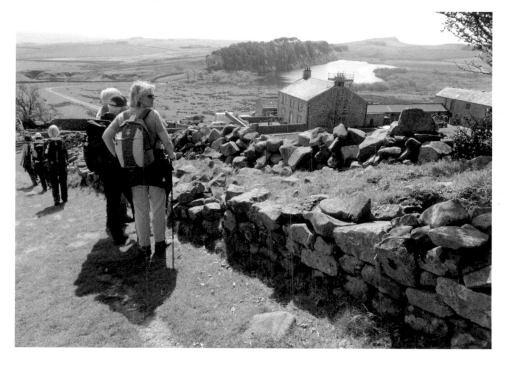

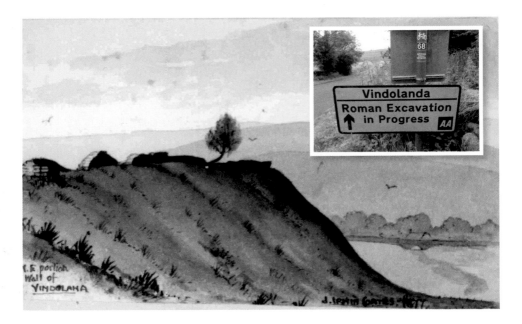

Vindolanda Fort

Vindolanda fort, south of the Wall, was built as one of the pre-Hadrianic forts. Excavations at Vindolanda fort and civilian settlement, carried out here since 1930, have been undertaken by three generations of the Birley family: Eric, Robin and now Andrew. The Vindolanda writing-tablets are an important source of information about life on the frontier before the construction of the Wall and the museum has an outstanding collection of artefacts from the excavations.

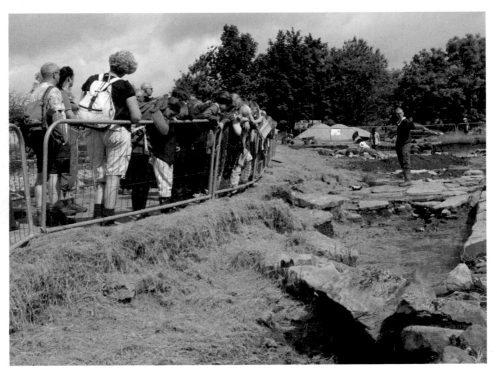

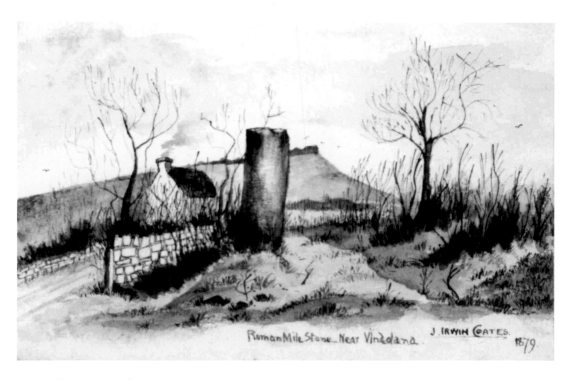

Roman Mile Stone Near Vindolana. J. IRWIN COATES. 1879.

Milestone on the Stanegate

A milestone column is *in situ* on the Stanegate close to the east entrance of Vindolanda fort. The remains of another milestone are located one Roman mile further west along the Stanegate, the medieval name for the Roman road that linked the forts between Corbridge and Carlisle.

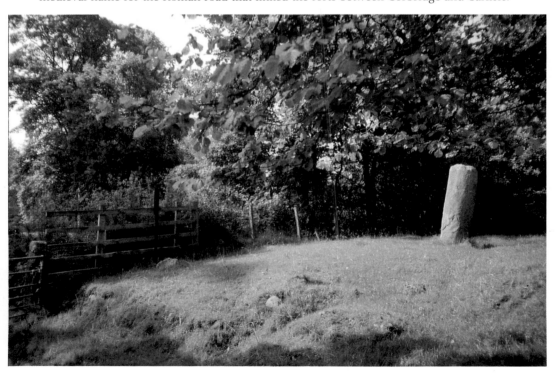

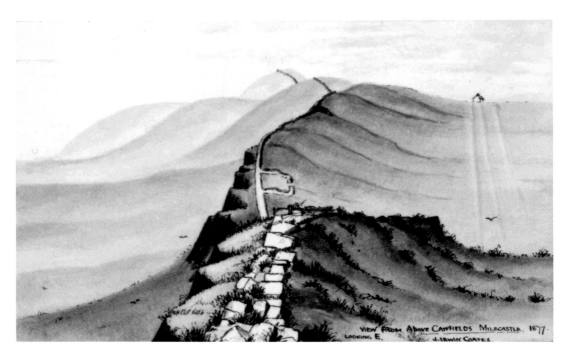

Cawfields Milecastle 42

Cawfields milecastle 42 was initially excavated by John Clayton in 1848. The section of Wall in the foreground has since been lost to quarrying. South of the Wall the distinct outline of the vallum is visible as is Shield-on-the-Wall farmhouse in the distance.

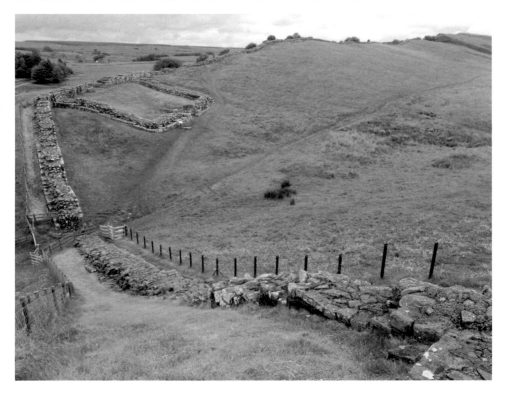

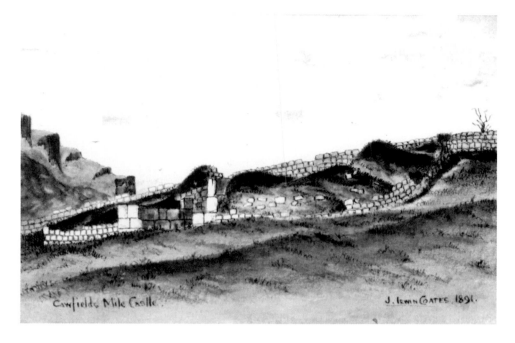

Cawfields Mile Castle. J. Irwin Coates. 1891.

Milecastle 42

Cawfields quarry, opened in 1902, lies slightly west of milecastle 42 and posed such a threat to the Wall that opposition to further extraction of whinstone for road building led to the Roman Wall and Vallum Preservation Scheme being passed by Parliament in 1938. When first uncovered by John Clayton in 1848 the milecastle was found to have 8 feet thick walls and still standing at least 7 courses high.

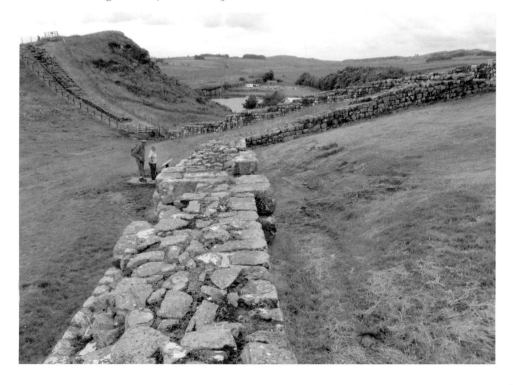

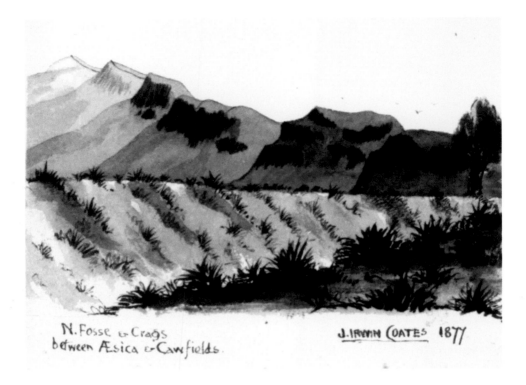

N. Fosse & Crags
between Æsica & Cawfields.

J. IRWIN COATES 1877

Cawfields Crags

The distinct outline of the north ditch, between Cawfields and Great Chesters fort, is visible as is the Wall on top of Cawfields Crags but once quarrying had commenced in the early twentieth century the section of Wall between Hole Gap and Haltwhistle Burn, including turret 42a, was demolished.

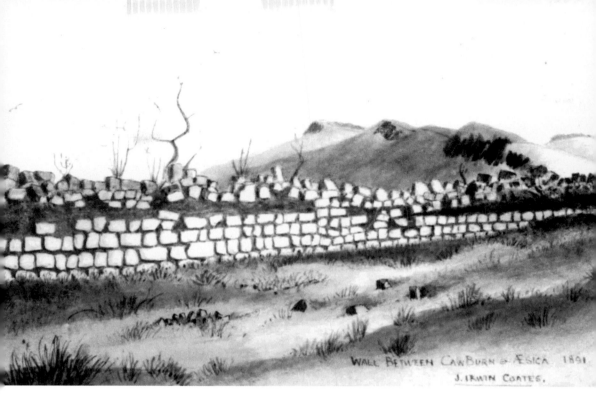

WALL BETWEEN CAW BURN & ÆSICA 1891
J. IRWIN COATES.

West of Haltwhistle Burn

West of Haltwhistle Burn several lengths of Wall stonework can still be seen incorporated within the south face of the later farm field walls. The line of the Wall can be followed eastwards as it clings to the Whin Sill escarpment.

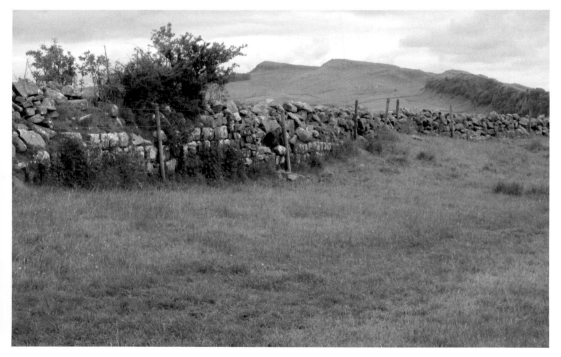

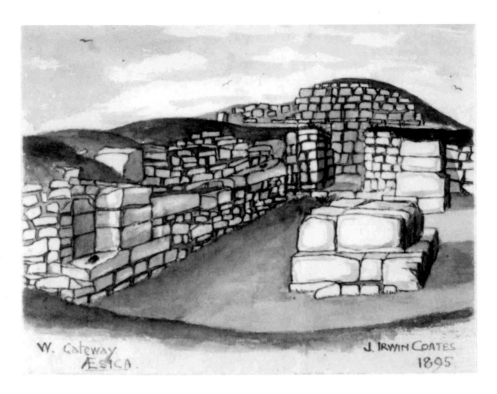

W. Gateway
AESICA.

J. IRWIN COATES
1895.

Great Chesters Fort I

Numerous segments of the privately owned Great Chesters fort (*Aesica*) were extensively excavated during the 1890s and again in 1925. Up until the mid-eighteenth century the walls of the fort were reported to still be standing 12 feet high. The west gate entranceway portals still retain the blocking walls which, fortuitiously, have been left in place by the 1890s excavators.

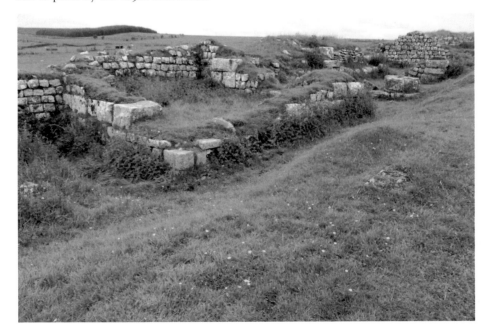

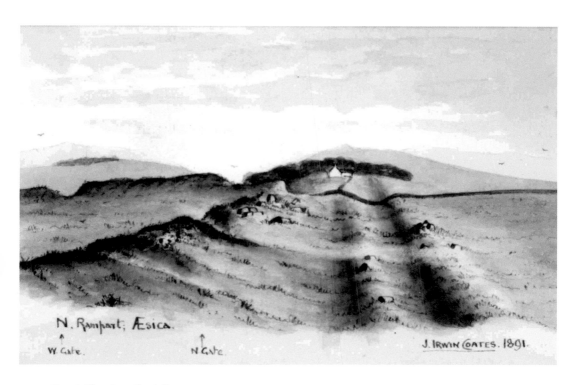

N. Rampart; Æsica.

W. Gate. N Gate. J. IRWIN COATES. 1891.

Great Chesters Fort II

The north rampart and north-west angle tower with the positions of the north and west gates indicated. The line of the Wall west of the fort is grass covered as it makes its way towards Cockmount Hill farmhouse and Cockmount Wood in the distance.

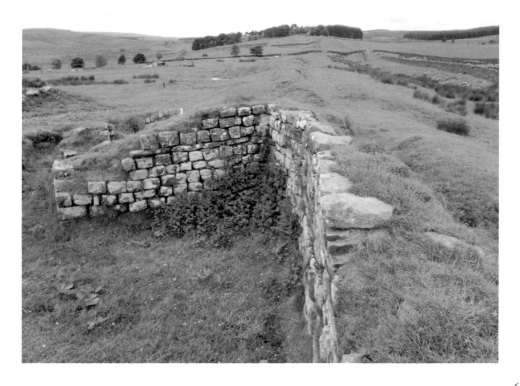

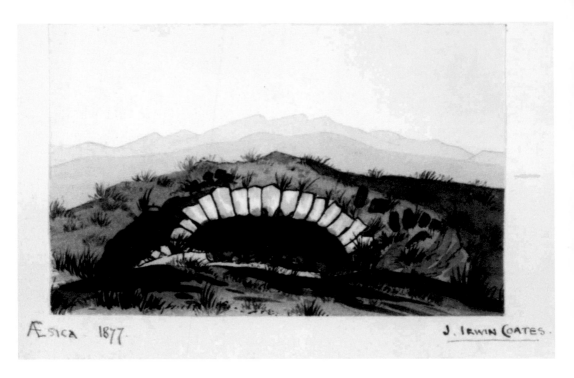

ÆSICA 1877. J. IRWIN COATES.

Strongroom Arch, Great Chesters Fort

The strongroom arch had first been uncovered in 1800 but it was not until the 1890s, after the visit by Coates, that it was fully cleaned out of rubble and debris. The roof voussoirs of the strongroom were consolidated in 1969 to protect it from collapse.

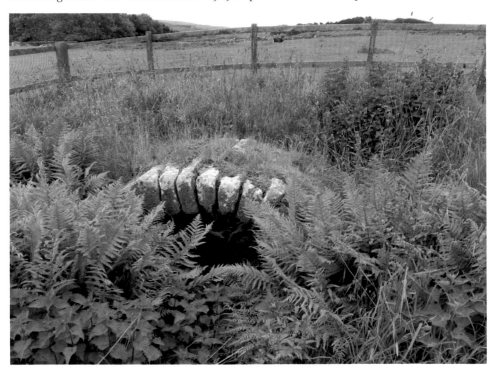

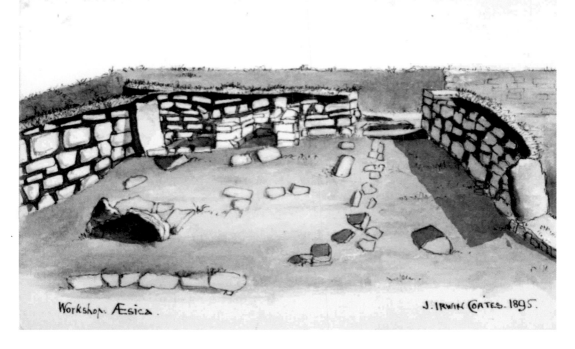

Workshop. Æsica. J. IRWIN COATES. 1895.

Workshop, Great Chesters Fort

The workshop or smithy was one of the buildings uncovered during the 1890s. At the south gate is a Roman altar where many of the Wall trail walkers passing through the site have left an offering for a safe journey.

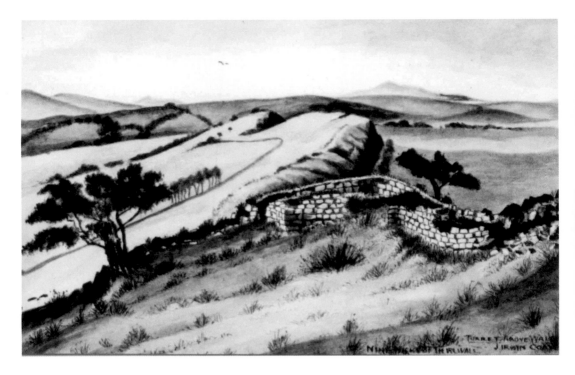

Turret 44b

Sitting on top of Mucklebank Crag is turret 44b overlooking the gap in the escarpment at Walltown Nick. The view westwards shows the line of the Wall as it follows the crags towards the site of turret 45a and Walltown quarry. Hadrian's Wall trail follows the line of the Wall as it winds its way across the south face of the slope.

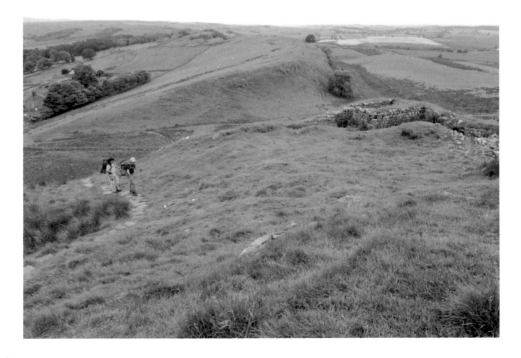

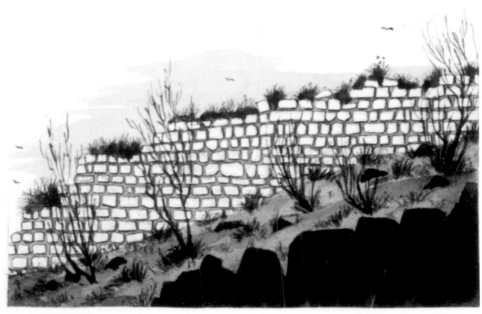

Wall on the Nicks of Thirlwall. J. IRWIN COATES 1877

Close to Turret 45a

The Wall, close to turret 45a, was built directly on top of the underlaying bedrock, with a drainage channel at the base to allow surplus water to pass through the wall structure. The south face of the monument shows the turf capped Wall with up to 16 courses surviving.

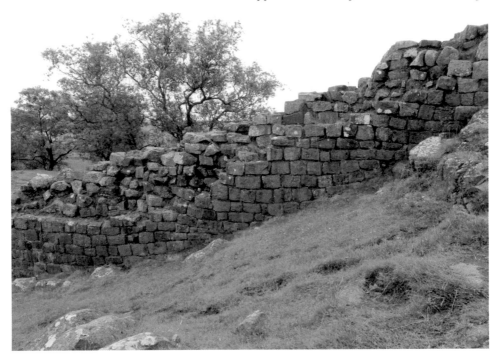

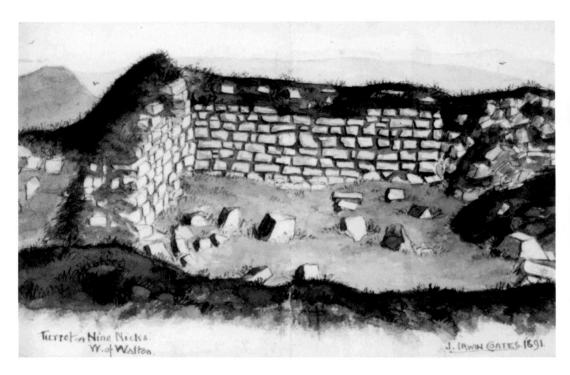

Turret on Nine Nicks.
W. of Walton.

J. IRWIN COATES 1891.

Turret 45a

Turret 45a at Walltown, sitting on the top of the crags, was initially exposed by John Clayton in 1886 prior to the visit along the Wall that year by the members of the Second Pilgrimage. Now Wall walkers use it as a convenient place to take a well earned break.

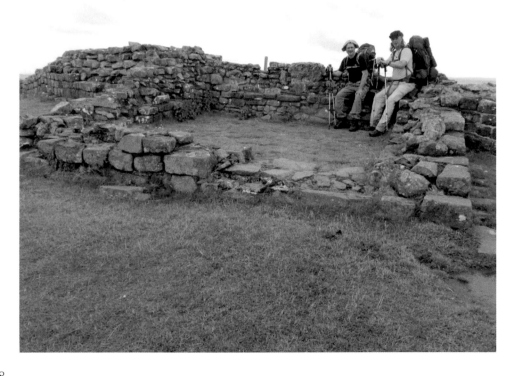

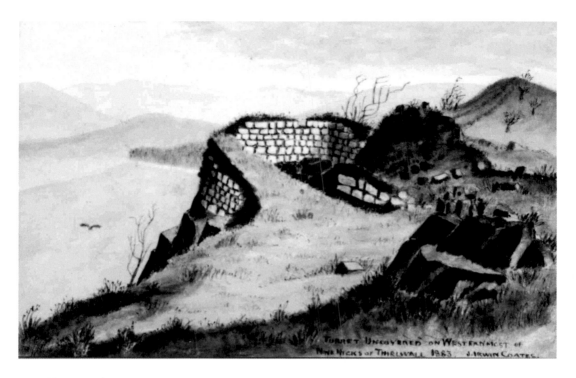

Turret 45b

The next turret along, 45b, was located in 1883 and destroyed shortly after when Walltown quarry began operations. The drawing by Coates, therefore, is very informative showing as it does 8 courses surviving in the west face of the turret. Operations at the quarry finally finished in 1943 and has now been landscaped into a picnic and wildlife area.

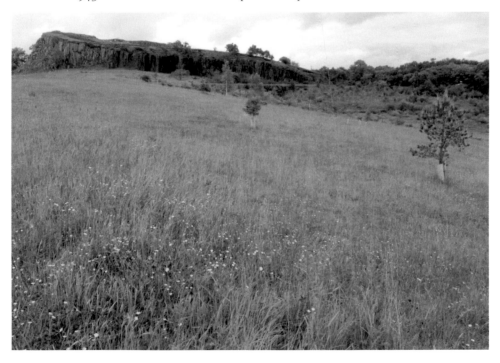

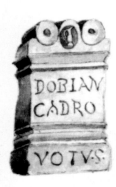
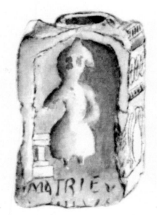
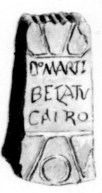

DOBIAN
CADRO

VOTVS

Altars found at Magna.

MATRIEV

D̄MARTI
BELATV
CAIRO

13 inches high.

12½" high. 7" broad.
Taken from Wall of Byre —
Sep. 1883.

9½ inches high.

J. IRWIN COATES. 1883.

Carvoran Fort

This delightful drawing by Coates shows three altars found at the fort of Carvoran (*Magna*) where the newly refurbished Roman Army Museum, managed by the Vindolanda Trust, is situated.

ROMAN ARMY
MUSEUM

Open

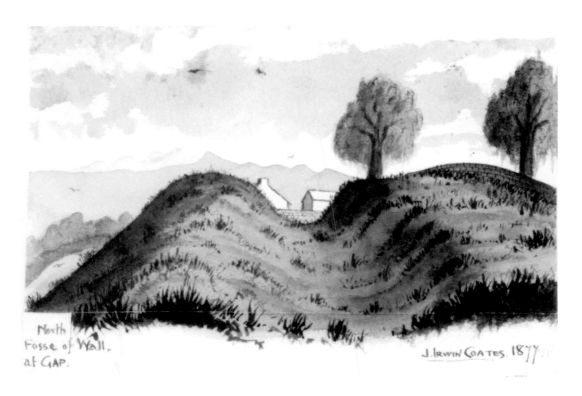

North Fosse of Wall, at GAP.

J. IRWIN COATES. 1877

Gap

Gap hamlet is situated on the east side of Gilsland close to the Northumbria–Cumbria boundary. Here the 50-foot-wide north ditch, with its impressive flanking mounds, provides a distinctive outline for trail walkers.

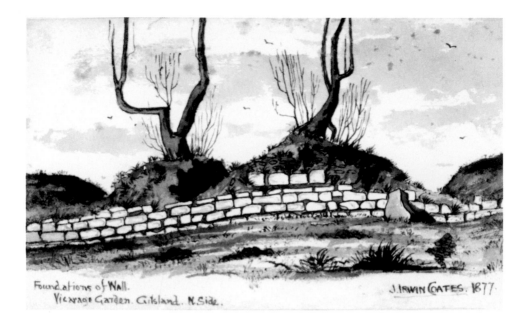

Foundations of Wall.
Vicarage Garden. Gilsland. N.Side.

J. IRWIN COATES. 1877.

Gilsland Vicarage

West of milecastle 48 and on the north side of the Carlisle–Newcastle railway the Wall runs through the garden of what was once the impressive Gilsland Vicarage. The later Hadrianic Narrow Wall here was built on top of the still uncompleted Broad Wall. Westwards, within the grounds of Willowford farm, is an extensive length of Wall, two turrets, sections of the north ditch and the remains of the Roman bridge over the River Irthing.

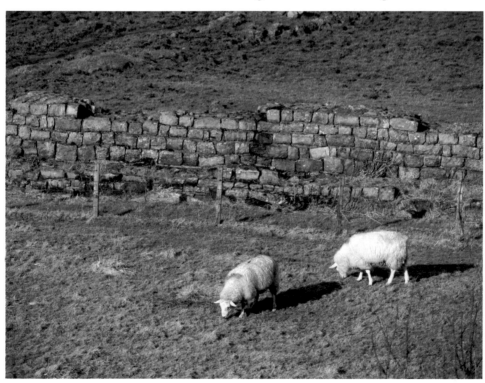

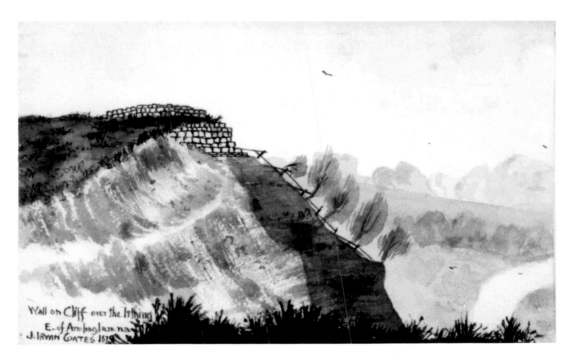

Wall on Cliff over the Irthing
E. of Amboglanna
J. IRWIN COATES 1879

Irthing River Crossing

West of Willowford farm the Wall crossed the River Irthing by means of a substantial and impressive stone built bridge before climbing the steep bank on the west flank to milecastle 49 (Harrow's Scar). A modern award winning metal bridge now spans the river giving walkers a safe crossing point.

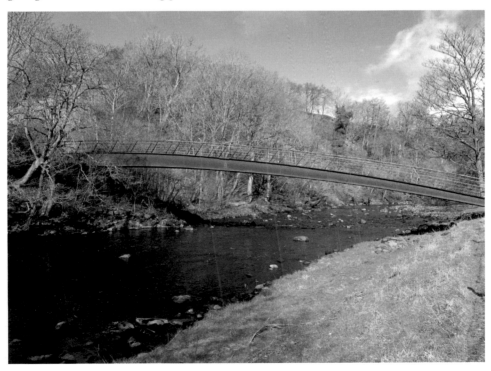

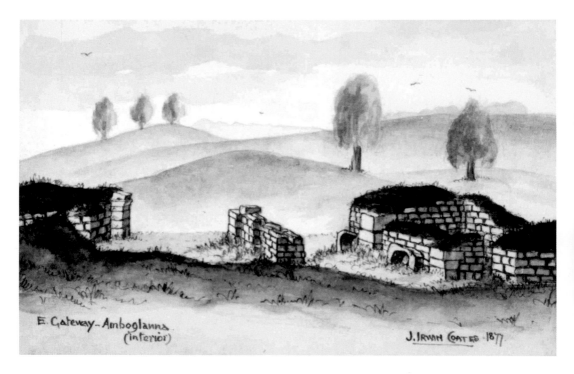

E. Gateway – Amboglanna
(interior)

J. IRWIN COATES · 1877

Birdoswald Fort

Birdoswald fort (*Banna*), covering 5.3 acres (2.14 ha), sits high on a promontory above the River Irthing and is managed by English Heritage. The well preserved east gate still has an arch stone in place and one of the window heads depicted against the south chamber has been re-used in the visitor centre café.

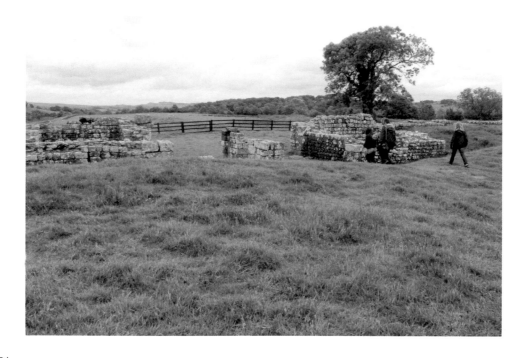

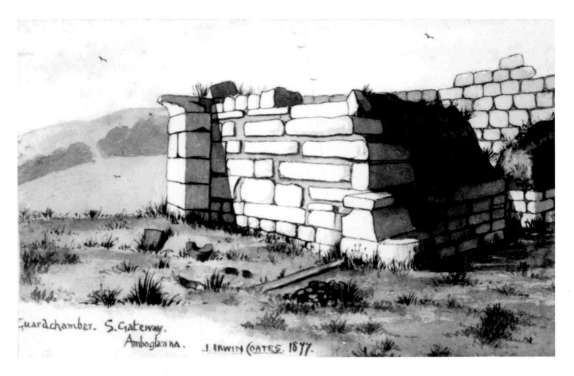

Guardchamber. S. Gateway.
Amboglanna. J. IRWIN COATES. 1877.

South Entrance, Birdoswald Fort

The south entrance was excavated in 1851 at which time the Roman blocking of the gateway was removed. The partially grass covered west chamber, rebuilt in the Roman period with large masonry blocks, shows the depth to which it had been covered by accumulated material.

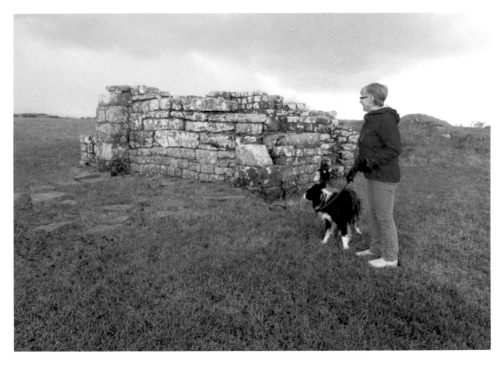

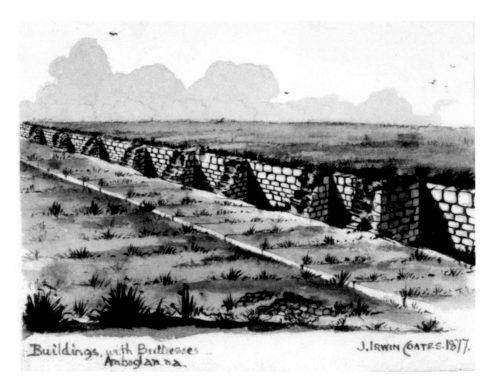

Buildings with Buttresses
Amboglanna

J. IRWIN COATES. 1877.

Buttressed Building, Birdoswald Fort

The buttressed building depicted in 1877 was excavated between 1987–92 by English Heritage archaeologist Tony Wilmott and found to be part of the two large granaries, some of the walls still standing 8 feet high. The late seventeenth-century Birdoswald farmhouse provides accomodation for both schools and groups on educational visits.

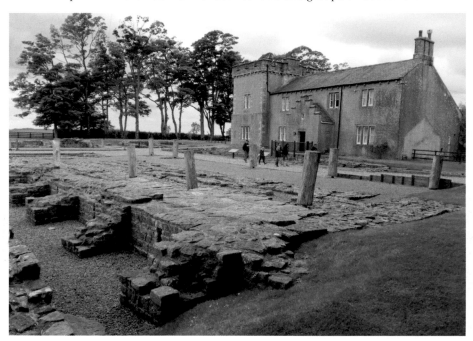

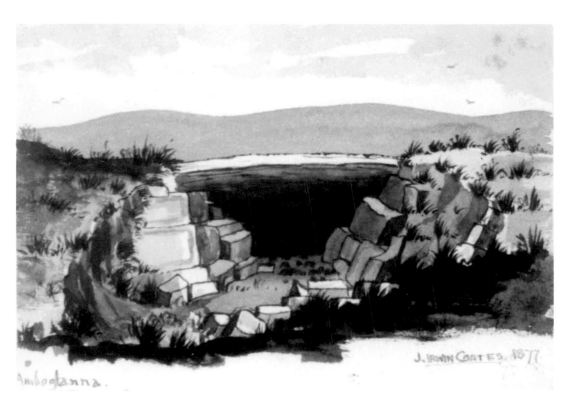

J. IRWIN COATES. 1877

Amboglanna.

Centre of Birdoswald Fort

In the centre of the fort close to where the headquarters building would have been situated is a large stone flooring slab that provides a great resting place for lambs.

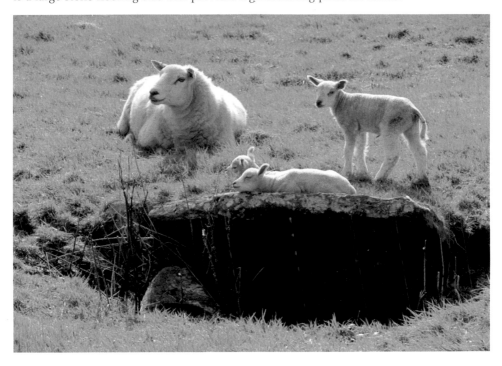

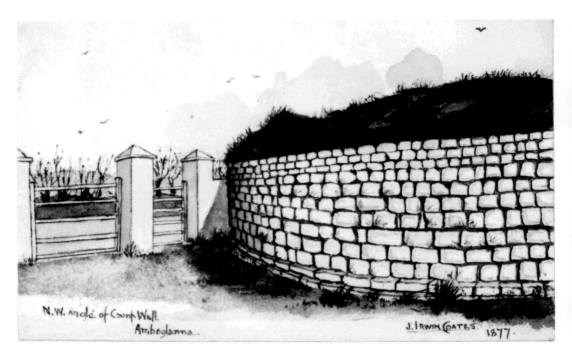

N.W. angle of Camp Wall
Amboglanna.

J.IRWIN COATES.
1877.

North West Tower, Birdoswald Fort

The north-west angle tower of the fort stands at least 10 courses high and had been uncovered in 1831 by the owner of the farm Thomas Crawhall, the first to carry out excavations on the site. Now the fort wall provides a backdrop for 'Maximus', a Roman centurian re-enactor, who provides an education focused programme for school children.

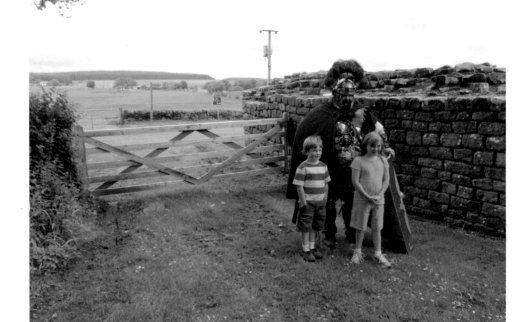

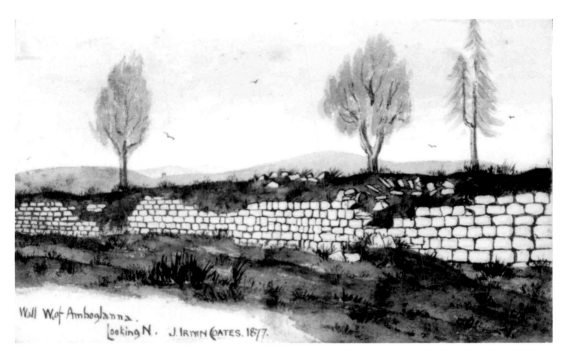

Wall W. of Amboglanna.
Looking N. J. IRWIN COATES. 1877.

West of Birdoswald
The south face of the Wall west of Birdoswald. On the north side of the Wall is the B6318, also known as the Military Road. In the distance is the only remaining wall of Triermain castle which had been built of stone robbed out of the Roman Wall.

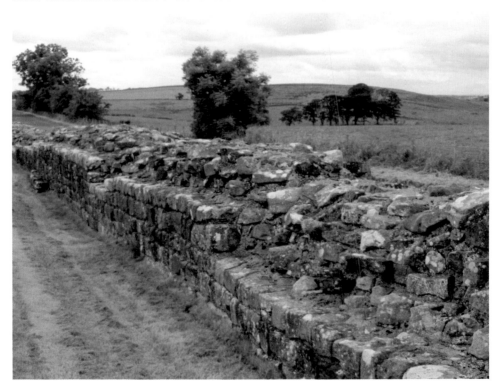

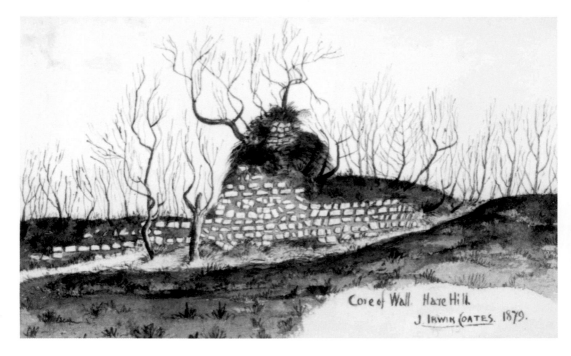

Core of Wall. Hare Hill
J. IRWIN COATES. 1879.

Hare Hill

This small section of Wall at Hare Hill, west of Banks hamlet, stands nearly 10 feet high but only the core and lower courses are original as the facing stones had been robbed out in the medieval period. In the late nineteenth century the north face was rebuilt by the Earl of Carlisle's architect Mr Marshall, who included a building stone of the *primus pilus*, the senior centurion of the First Cohort.

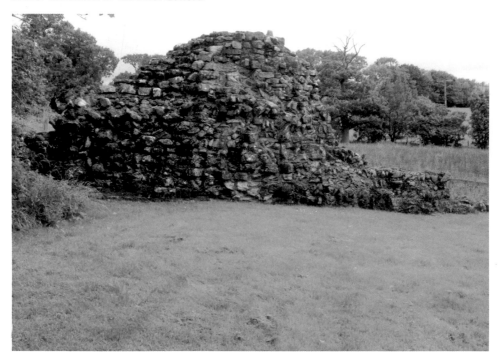

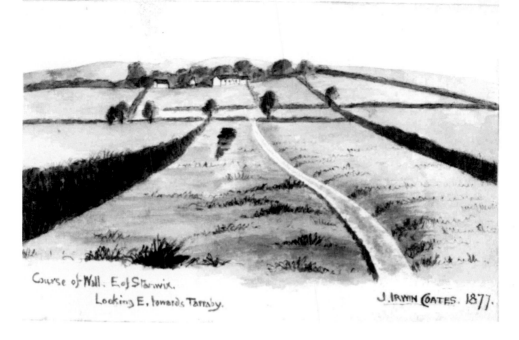

Course of Wall. E of Stanwix.
Looking E, towards Tarraby.

J. IRWIN COATES. 1877.

Tarraby

On the eastern outskirts of Carlisle lies the village of Tarraby, which sits astride the Wall. A medieval packhorse route, now Tarraby Lane, followed the line of the Wall well into the nineteenth century.

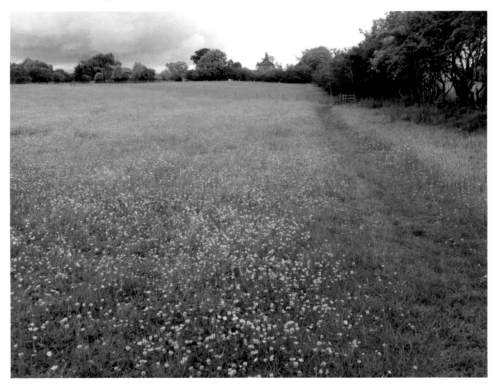

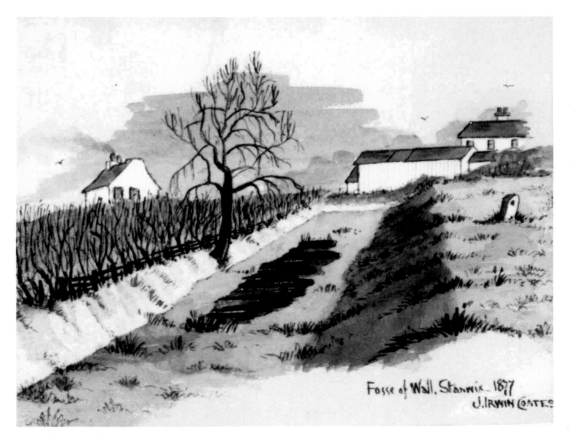

Fosse of Wall, Stanwix 1877
J. IRWIN COATES

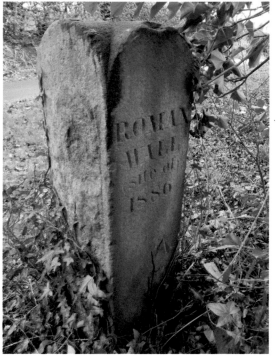

Stanwix

The Wall reaches Stanwix (*Petriana*), Carlisle, where the largest fort along the Wall (9.75 acres, 3.96 ha) was built. A stone marker opposite Aughton House in Cavendish Terrace indicates the point where the Wall heads down to the River Eden. On the west bank of the river pieces of the Roman bridge, which was dredged up in 1951, are laid out for public view.

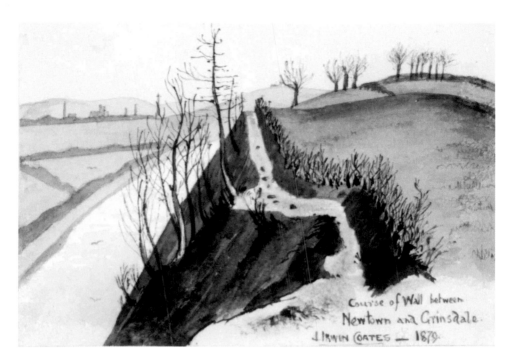

Course of Wall between Newtown and Grinsdale. J. IRWIN COATES — 1879.

Grinsdale

West of Carlisle near the hamlet of Grinsdale the Wall, shown as a raised mound covered in vegetation, follows the south bank of the River Eden. The newly opened Carlisle bypass crosses the river and the line of the Wall at this point.

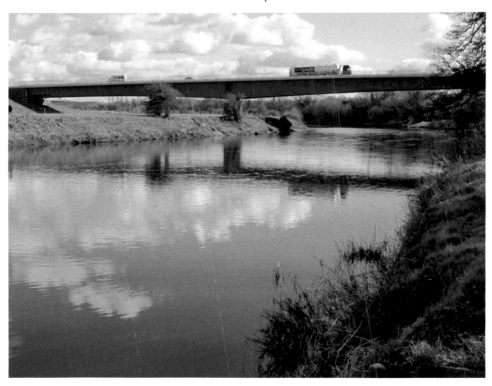

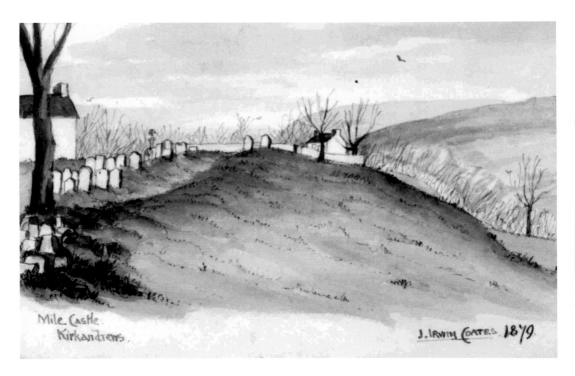

Mile Castle.
Kirkandrews.

J. IRWIN COATES. 1879.

Kirkandrews-on-Eden

The view in 1879 is of the graveyard of the now demolished Kirkandrews-on-Eden church. An earlier twelfth-century church dedicated to St Andrew had been built here and the pile of stones next to the tree, perhaps re-used Roman material, may relate to that structure.

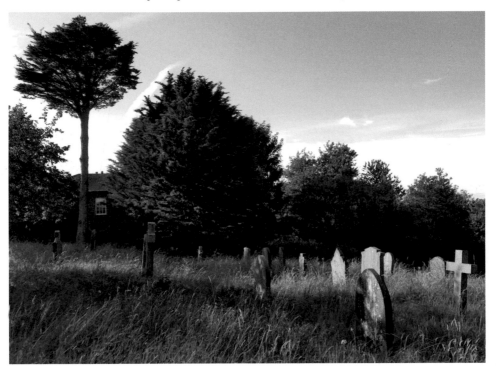

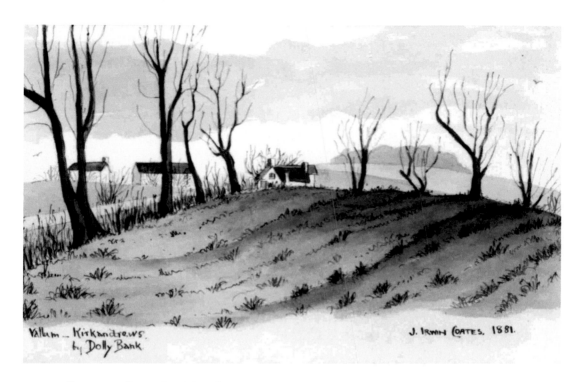

Vallum — Kirkandrews
by Dolly Bank

J. IRWIN COATES. 1881.

Vallum at Dolly Bank, Kirkandrews-on-Eden

The vallum at Dolly Bank, Kirkandrews-on-Eden, with the Carlisle–Bowness road on the left and several of the village buildings.

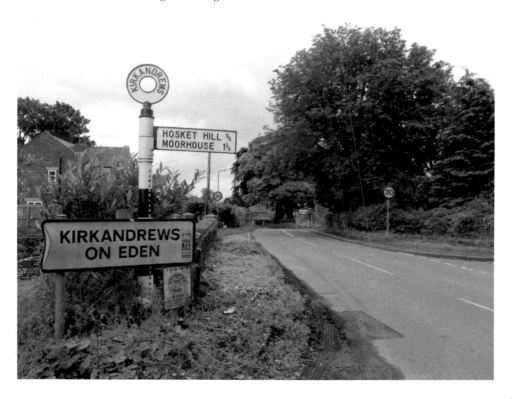

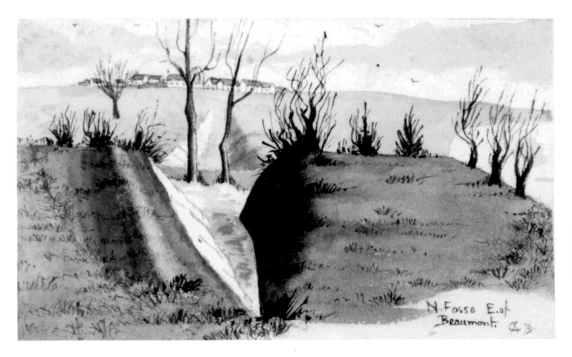

N. Fosse E. of Beaumont.

Beaumont

The depiction showing the banks of the River Eden, the low mound of the Wall and the north ditch on the east side of Beaumont also shows eight buildings within the village as well as the church of St Mary.

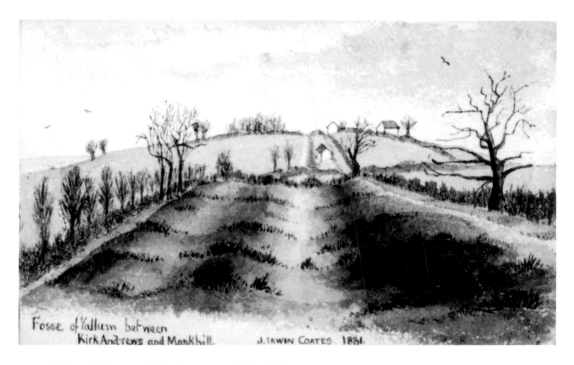

Fosse of Vallum between KirkAndrews and Monkhill. J. IRWIN COATES 1881.

Vallum Between Kirkandrews and Monkhill

The vallum, looking west, between Kirkandrews and Monkhill in 1881 with the Carlisle–Bowness road on the right. Three buildings in the village are depicted, probably including the Drovers Rest public house.

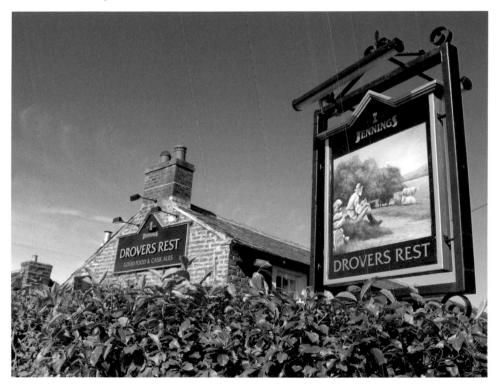

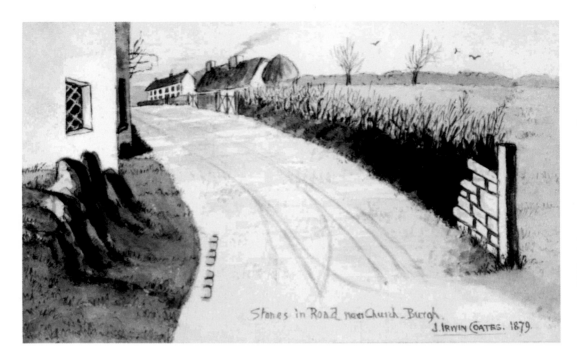

Stones in Road near Church Burgh.

J. IRWIN COATES. 1879.

Burgh-by-Sands 1

The Coates drawing of 1879 shows the road leading into the east end of Burgh-by-Sands village with 7 courses of the north face of the Wall showing through the surface. Desmene Farm, with a haystack at the east end, is on the north side of the road and the old vicarage with a lattice window is on the south side.

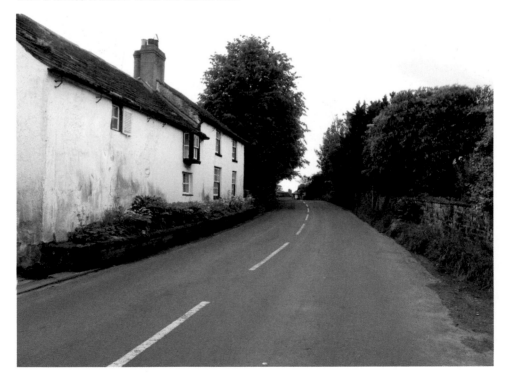

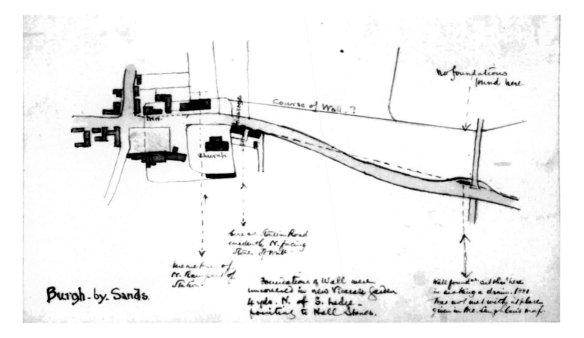

Burgh-by-Sands.

Burgh-by-Sands II

The map of Burgh-by-Sands shows not only various buildings within the village but also the outline of the 5-acre fort (*Aballava*) and the late thirteenth-century church of St Michael, partly built of Roman stone, within the south-east corner of the fort. Archaeological evidence from along the Wall shows that many of the forts, milecastles and turrets were re-occupied in the twelfth to fourteenth centuries.

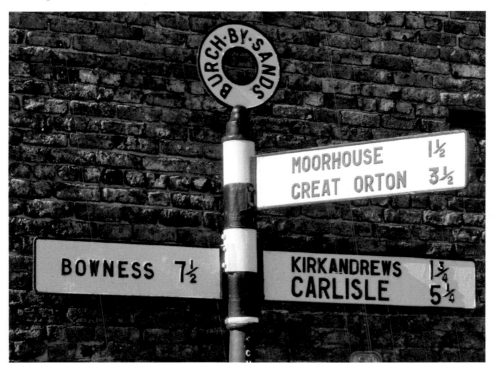

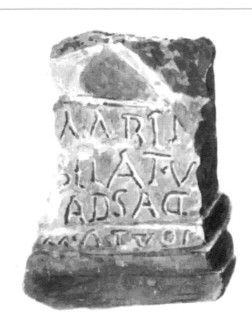

Altar found in Window of Church Burgh 1881 (Half size)

J. IRWIN COATES. 1881

Sandstone Altar
This small sandstone altar, noticed by Coates in 1881, was on the window ledge of the church at Burgh-by-Sands and is now in Tullie House guseum, Carlisle. The inscription dedicates it to Mars Belatucadrus, a Germanic god associated with the Roman god Mars.

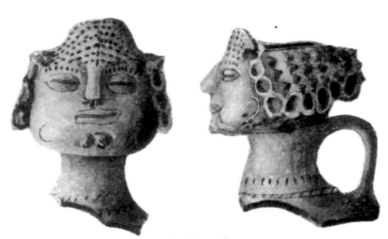

Mouth of Urn. Burgh.

Found when digging Foundations of new Vicarage, 1885. J. IRWIN COATES, 1885

(About Half Size.)

Pottery Urn

Part of a third–fourth-century pottery urn showing the head and neck of a female figure with her hair in ringlets and the stippling possibly representing body decoration. Found when the foundations of the new vicarage were being dug, the piece is now on display in Tullie House Museum.

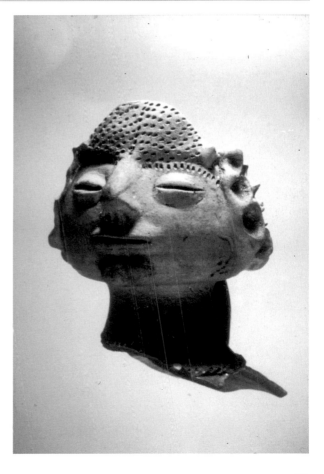

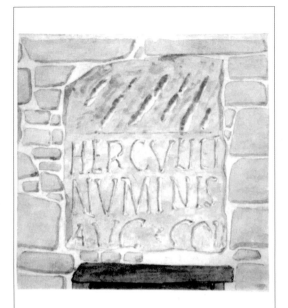

Part of Altar – Burgh built in over the door of
Mr. Armstrong's Barn.

J. IRWIN COATES. 1882.

Small Altar
The small altar, dedicated to Hercules and
the deity of the Emperor by a detachment
of Roman soldiers, was found close to
Burgh-by-Sands fort and is now in the west
wall of an outbuilding at Cross Farm.

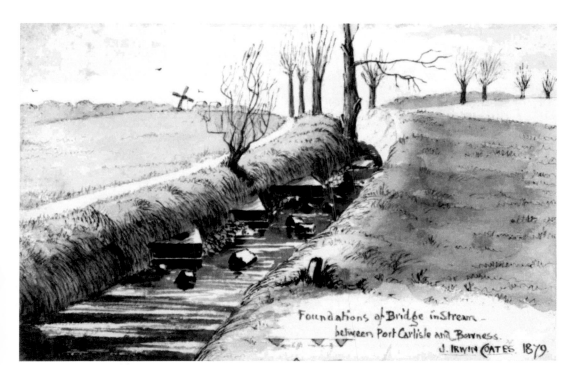

Foundations of Bridge in Stream
between Port Carlisle and Bowness.
J. IRWIN COATES. 1879.

Stream Between Port Carlisle and Bowness

The small stream between Port Carlisle and Bowness has several large wedge-shaped blocks exposed in the banksides, probably associated with a small Roman culvert or bridge. Similar culverts have been seen at West Denton Burn and Rudchester Burn. In the background is the Bowness windmill.

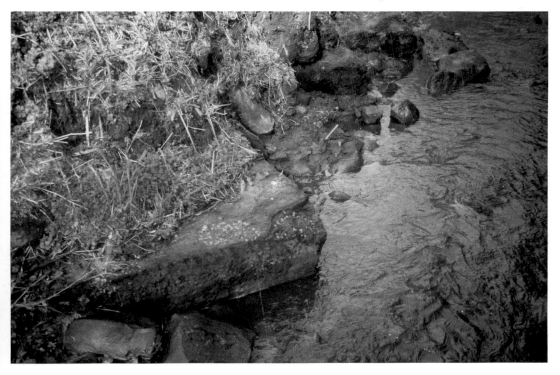

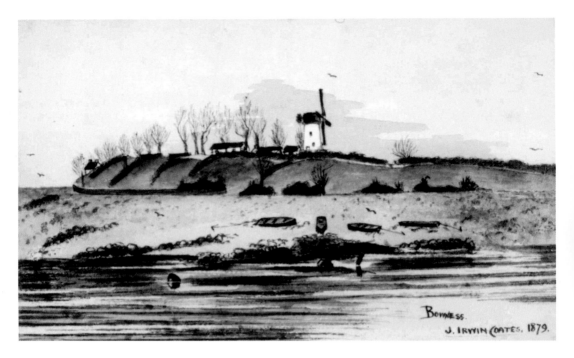

Bowness.
J. IRWIN COATES. 1879.

Bowness Fort

Bowness fort (*Maia*) laying at the western end of the frontier Wall covers 5.7 acres (2.3 ha) but most of the fort is buried under present buildings. The present day road through the centre of the village respects the position of the east and west gates of the Roman fort. The view, of the Solway shore at low tide with four small boats, depicts Bowness windmill with four sails or 'sweeps' and several buildings in the north-west corner of the fort. The windmill, owned by Sarah Lawson, was demolished between 1880 and 1885.

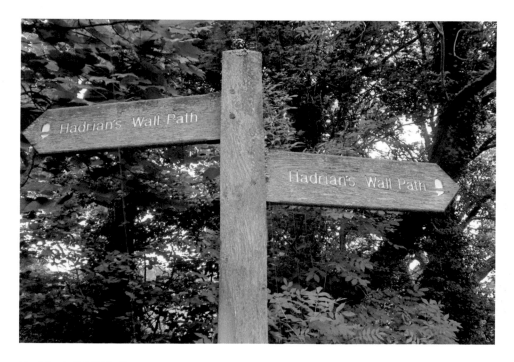

Hadrian's Wall Trail I

The 84-mile-long Hadrian's Wall Trail between Wallsend and Bowness was opened in 2003 and has become a very popular walk for people of all ages from all over the world. A dedicated team of Trail volunteers and staff ensure the trail is kept clean, tidy and well maintained as it follows the line of the Wall. A Roman themed pergola at Bowness greets all of the happy walkers at the end of their accomplishment.

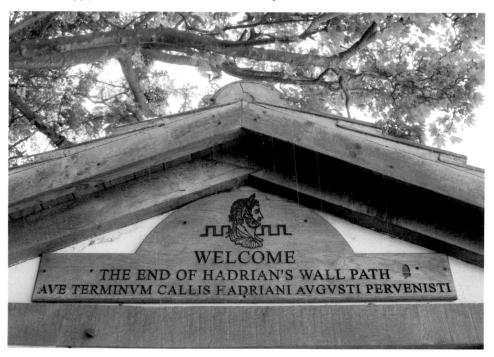

Hadrian's Wall Trail II

In 2010 the entire length of the Hadrian's Wall Trail was illuminated by a series of beacons and visitors from here and abroad came to see this spectacular event as part of the build up to the 2012 Olympic Games. The AD122 Hadrian's Wall bus is a popular and sustainable way for visitors to access not only the various World Heritage Sites but also the Hadrian's Wall National Trail.

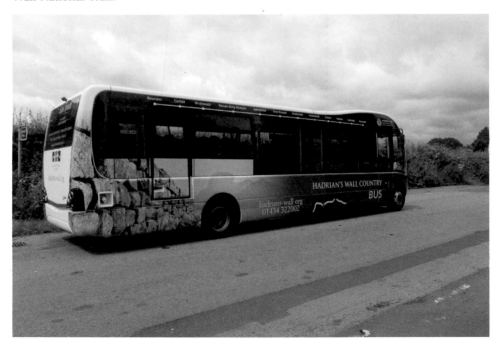